How to Handle Your Relationship

How to Handle Your Relationship

Judith Carol Cole

iUniverse, Inc.
New York Bloomington

iUniverse books may be ordered through booksellers or by contacting:

iUniverse
1663 Liberty Drive
Bloomington, IN 47403
www.iuniverse.com
1-800-Authors (1-800-288-4677)

Because of the dynamic nature of the Internet, any Web addresses or links contained in this book may have changed since publication and may no longer be valid. The views expressed in this work are solely those of the author and do not necessarily reflect the views of the publisher, and the publisher hereby disclaims any responsibility for them. The cases presented in this book are real life experiences. To protect annomininity, the names may have been omitted

ISBN: 978-1-4401-8167-2 (pbk)
ISBN: 978-1-4401-8168-9 (ebk)

Printed in the United States of America

iUniverse rev. date: 5/19/10

Table of Contents

Chapter 1 Commitment ...1

Chapter 2 Investigating your Pro's and Con's42

Chapter 3 How to Succeed When the Negatives Are
Against You ...78

Chapter 4 Marriage Vows..111

Chapter 5 Knowing you have arrived into the
Kingdom of God..133

Chapter 6 Final Summary..163

Chapter 7 Quiz..179

Frequently asked questions198

Remarks from the desk of Attorney Ginger
Byrd: "What it takes to achieve a successful
life." ..218

Collaboration of Prayers....................................219

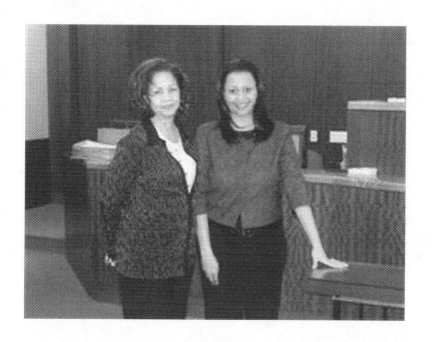

Foreword

About the Author:

Judith Carol Cole, better known as Judi was born and reared in Wichita, Kansas and she attended the State University along with completing Interior Designs School. Judith uses research from her 17 years of bible study in preparation for this book. She frequently says that her life is a continual daily Bible study.

Judith is currently living in Humble, Texas and is an inspired single that is in love with the Lord. She currently works along side her daughter Ginger Byrd, in a new law firm located in Humble, Texas and writes Christian inspired Books.

The Author's objective is to become a new, fresh and inspiring Christian Author who relates to relationships for couples in crisis.

Judith has worked in the legal field in Washington D.C. and has always had an interest in assisting with justice.

This Book is directed towards singles in crisis who are expecting to get married; however it will also enhance and refresh couples who are married. This book will assist those who just want to feel inspired and encouraged in keeping their current relationship revived and exciting.

The Holy Bible will direct you into the order in which you must go. In reading this book you will find the answers to your crisis. With 17+ years of knowledge being compressed into one single issue in this book, it is amazing that all the research of Biblical doctrine becomes an unraveling of revelation that will teach you what the Bible has to say about your current relationship and what it will take to become successful in your life.

In addition, you are about to receive informative keys that will unlock the door to many issues that may have caused your crisis.

From the Author:

The Bible teaches that there is a process that takes place that allows us to connect with God. This is where a transformation of the mind has to take place from the physical being into the super natural. It will be necessary that together, you and I are transformed into the Spirit, where, we will find God. That will be our meeting place.

This Book will connect you with God in the Spirit. We are about to enter into the supernatural by using the Word of God; who represents our freedom. The Bible teaches that the truth that will set you free.

When Jesus died on that old rugged cross, and he took our sins with him baring them for us; your sins were casted into the sea of forgotten sins; as far as the North is from the South and East is from the West.

There is no perfect person on earth we are all sinners, there is present help and there is hope. God designed us all knowing that we will engage in making mistakes. He has made allowances for our mistakes.

God realizes the oppressions of Satan and the struggles that we have to endure in our daily walk. God knows that Satan is real and roams around the earth with his mission to kill, steal and destroy mankind.

Good always trumps bad.

When Jesus died on the cross he made a path for us that

cleared the way so that we do not have to worry about our past sins. God has forgiven all believers!

Read: Galatians Chapter 3. It contains great revelations and teaches in these areas.

We are taught that God says:

"Your sins have been forgiven; if you abide in me I will abide in you." You no longer have to live in bondage, you have already been set free to live and love again. Jesus Christ paid for your freedom! Not only are you free, but the judgment that you will receive before the throne of God will be to receive your rewards. Isn't that good news? Never allow condemnation for your life.

It is imperative that you begin to apply this Christian method to your current relationship. You will need to release your faith. Using the Word of God, along with your faith are the two tools that will bring you to get your victory.

Your access has been granted you are free to enter into the Throne Room of God.

This book contains a fool proof method that holds your guarantee.

The major criteria for the climbing divorce rates and the breakups in relationships are that there are not enough loving stable, relationships and a lack of strong Christian male leadership. Sometime in recent decades, the roles have been redefined. There is in some cases, a reversal of role definitions. Your answer to your crisis is in this book.

Until society returns to the loving emotional stimulus and incorporate it into your daily relationships; there no doubt, be a continuation of divorces in relationships as we will continue to see the rising crime on the streets.

From the Author:

First of all, I wish to extend my thanks to our Lord and Savior who is a great and omnipotent God! And to Jesus Christ! I wish to dedicate this Book to the Almighty Father; so that through me; his living vessel, his Word can be received by those who are experiencing relationship crisis, as well as for those who will be making a decision to enter into a relationship and for the couples who are already married.

Without God it would have been impossible to write this Book.

Secondly, I would like to thank my family. I have two daughters that are successful adult ladies. Both have tremendous skills to comfort those in need. In addition, to serving in their professions, they have been there for me when times were tough and offered their support and advice. Amazingly, our children can be our greatest advisors. Unselfishly, they put forward time and effort so our family could get back up and onto the saddle again when adversities presented

themselves. There came a time when I had to come to grips with the adversities in my life and take control of it; taking back what the enemy had stolen from me.

I am also the grandmother of two precious grand daughters of which I am thankful to be their grand mother. They are exceptionally gifted and very successful in their precious lives.

My oldest daughter, Stephanie Howard, is a Realtor married to Kenny Howard. In addition, to being a powerful woman of God, she directs a Christian Outreach, located in Desoto, Texas, of which I am a Director. The Outreach's purpose is to feed the hungry and help to save the lost and carry out the Mission of God. Stephanie is the mother to my oldest granddaughter Quinn Love Cole, who carries a great deal of exceptional beauty. She holds a black belt of beauty in the family along with being intelligent and hard working. She is also an aspiring model and singer.

Ginger Byrd A.K.A my youngest daughter is an attorney. The Legal Practice is located in Humble, Texas. She is married to Jayson Byrd F.R.A.T. who is a Mechanical Engineer. Together they have a daughter, Alexia, who is talented and gifted and ranks at the top of her class and continues to stay on the honor role. She is 10 years old. Alexia and Quinn are true blessings from God.

There are many family members and friends of whom I want to thank you all and tell you how much I appreciate you. My parents and grand parents are all deceased except for my mother who is still alive and lives in Kansas. I am very grateful to have her as my

mother. *Much love and thanks goes out to all. You have all played a significant role in making my life the success it is today.*

NOTE:

Ironically, I have found that the 'Reader's mood' has everything to do with how well you enjoy and comprehend this book and rate it. Pick it up to read when you are in a spectacular mood so that you can fully grasp the magnitude and exorbitant energies that will come from this book, as you are lifted up anointed and connected with me and with our Heavenly Father. It doesn't get any better than this!

This book is about overcoming your crisis in your relationship and teaches you how to become victorious within yourself first; then how to apply your "oneness" as wholeness into your relationship or marriage.

Join in with me in the prayers that will be coming up throughout this Book.

"Holy Spirit you are welcome in this place Omnipotent Father of mercy and grace you is welcomed in this place".

Chapter one Commitment

We are finding ways to define when and why one should Commit. The definition of commitment in a relationship sense of the word is a promise to take the path of marriage as one's ultimate goal.

The lady's point of view:

All too often, women in their relationships, are ultimately coming away from unsuccessful relationships with a feeling of being *"used"* and "taken advantage of." This is usually predicated by the fact that she has emotionally fallen in love with her partner and she has dated him exclusively, for a substantial time. She feels she has put in time and effort and presented him with her best, yet he has not spoken the words *"Will you marry me?"* She is now left with feeling confused, not knowing how to identify the problem; left unattended, this will consequently consume her.

She is now peaked out to the top of her level of understanding and becomes understandably concerned.

Advice for these ladies:

A remarkably climbing percentage of ladies are trapped in this antagonizing situation. Far too many relationships have failed due to the fact that in many cases the female partner waits with anticipation for her male partner to propose to her the old fashioned way.

The adaptation of women proposing to the men is one that is not rapidly acceptable for a large percentage of ladies as they are still waiting on their men to take that leap. Although, this thought process may be looked upon as old fashioned, it is often typical that a woman will designate a "waiting period" so to speak, a minimum of approximately 3 months or longer for this development to occur, there is no definite standard time limit; however, you are urged to set some rules. As a rule general rule of thumb, in this book I use 3 to 6 months as a guide to give you an impression of a timely manner; although couples gravitate at different paces.

Commitment can be defined as an unresolved problem or looked upon as a victory. It is where relationships are birthed. This area, the courtship area is the battle ground where you determine who you will be sharing your life with.

The issue of single parenting and children who are coping with single parenting has a close association with crime on our

streets however, this book is primarily about improving the quality of our love life and offers *biblical* restitution keys.

Her assessment is that those spoken words, "*Will you marry me?*" are not being resonated to her and will not be spoken to her in that relationship she is about to experience an infuriating emotional setback. There is obviously a break down in the area of communication that will consequently lead to a perplexing and alarming negative situation causing her to now panic. This is especially true if they have experienced intimacy. She has to discern his silence; after her designated waiting period allotted has expired and she feels as though it is pointless to confront him about his silence. She fears that approaching him could cause him to oscillate and become defensive. It could be that his silence is an indication that he is not ready to commit or possibly will never commit to her. Therefore, she will need to investigate whether marriage will be obtainable or if there is no possibility for marriage.

Occasionally, you will find a female who finds it appropriate and is willing to propose to her male partner. Contrary, many females find it offensive when they have to take the lead in promoting the relationship; causing her to take the responsibility of carrying the lead. It leaves many with a feeling of being violated, humiliated and not appreciated.

One major component in resolving this issue for ladies is that you must realize that men are also in quest of how they can best benefit from having you in their lives. *No one is looking for baggage.* Men do not choose to marry into drama.

In order to achieve a successful marriage you will have to have your act together. You will have to show him and prove to him how he is better off with you than living without you. The male knows immediately if she is right for him.

Your work is cut out for you. For those ladies who have managed to pull this off, you have obviously shown him the assets that he is seeking in his partner. There are weddings that are continually happening. The question is: Are they successful marriages and will they last?

If you are not being fully represented or getting what you expected out of your relationship, it is not necessarily your fault or a short coming of yours. It could be that *he is not qualified for you,* so don't panic. You will have to become precise in your judgment on many levels while you are determining what it will take from you to get where you should be in your relationship walk.

Men are basically not as open as the women and as a rule women tend to be more sharing of information about themselves and their relationship.

Let's review what you are up against:

Confronting him could cause feuds; he may not know himself why your relationship is going nowhere. To convey to you how to identify your problem you will need to begin to investigate; finding out what and who has been holding you back from getting what you deserve from your investments in this

relationship. Evaluating the amount of time you have put in, the emotional damage you received alone are costly.

God has your answer. It is specifically designed for your situation. You must first give to God in prayer; believe that when you leave it with God that your answer will come. Wait on the Lord until your due season. God is big enough that he knows your needs. He says in his word that *he will supply your needs.* You must believe in God in order to get yourself back to becoming functional and victorious. The breakup or crisis coming from a relationship or marriage can create devastation and a broken heart which is not easily healed. The love emotion is so very powerful that it is crucial that one handles their relationship with *caution.*

Remember, we are *faith*-believers therefore, unless you have faith to believe that God changes things, this book will not help you. On the other hand if you can manage to get yourself into a *receiving mode* spiritually speaking, you will be astonished how the Spirit of God is going to sustain you and your crisis as God moves while you are reading *this powerfully Anointed Book!*

Let us start the investigation by means of using the process of elimination. First, you must identify what is causing you to have a negative reaction. List them. What are the problems? Next, who is causing the problems? You can expect to let go and release the negative people and thoroughly investigate your negative strongholds. What are situations that hinder you? What are the deterrent forces that are holding you back? Once you have laid it out there you will be able to see for yourself what you have before you.

To begin, it will be necessary for you to become embellished with an environment that is functional, a peaceful place where the Spirit can flow freely. There is nothing more distracting than living in an environmental where you are not happy and there are diversions in the environment that are taking away from your true purposes in life. Those negative traits and unsolved issues that you may be enduring are distractions and will destroy your vision. *Without vision the people perish.*

After your environment is in conjunction with the proper atmosphere and you have obtained an open mind; that allows you to venture into finding and excelling in the area of *Spiritual Soul Searching.* This is in your secured place where the Spirit of God can minister to you. It is imperative that you have an open mind that allows you to connect with your Godly Spirit so you can begin an empowered search for a healthy fulfilled life for yourself on a personal basis, first, as an individual, and then you qualify yourself as bringing a qualified means of giving to the table of offering for a healthy and intimate relationship and marriage.

You are now, investigating and finding ways to become champions over your relational crisis. At this point, your next priority is to search for compatibility.

You are in a transitioning period. Your first major focus will be to be all that you can be. In the building up of one's self esteem, self assurance and self concept, you will have earned the rights to seek out the best compatibility available to you.

The person you select should be someone who can accept you just as you are, rather than a partner who is a fault finder and has the need to change who you are. You are seeking minimal compromise. Your partner should be someone who is willing to allow a broad margin for growth so that you can be yourself and grow into that place of perfection you are trying to reach in your relationship.

There are three major components that people generally looked at when choosing their life long partner:

a. Physical traits: Although, looks may appear to have very much to do with the quality of one's character, physical attributes is what men look to first, when they are choosing who to approach. Your appearance carries a great deal of significance, however, it is not enough alone. You will need substance. Nevertheless, it is noted that a woman's physical traits and appearance rates as top characteristic.

b. Status: A person's social economic status includes their education, profession and earning potential. In addition, a person's credit and amount of debt contributes to this status. This is important because this impacts a couple's lifestyle. Typically, women are looking for stability and security. Neither is looking for baggage. This trait is important in seeking compatibility.

c. Personality: Your personality carries great significance. Whether you are an introvert or an extrovert. Are you best suited with an outgoing partner or laid back?

Are you dealing with a passive personality or really a passive aggressive personality? These questions are important especially when determining long-term compatibility.

Before you say the words *I do,* know beyond a doubt that you have chosen the most compatible person, by using keys outlined in this book that were derived through the Bible.

There are six categories listed for both males and females that will describe what each is seeking from their relationships.

a. Types of men:

b. There is the committed type

c. There is the not sure type

d. There is the manipulator type

e. There is the uncommitted type

f. There is the upfront confrontational type

g. There is the compromiser or victorious type.

The committed type:

This is the type of male who is searching for his lifetime bride. He is onboard and ready for action and in favor of doing the honorable thing. He basically, has his life in tact and has a vacancy for finding a wife.

The not sure type:

This guy does not have a clue what he is in search of from his relationship. He just cruises along daily with the attitude that

whatever happens just happens. He carries no responsibilities for his actions and appears not to know if he wants marriage, commitment, friendship or a pen-pal.

Manipulator type:

He will tell you his intentions are honorable just to get what he wants from you then he is will to dump you. He has no intentions for marriage. He makes promises that he can't or doesn't intend on keeping. Basically, he goes from female to female using them as his prey.

Uncommitted type:

This type of guy is the one who will never marry. He finds that all women lack the qualities and fail to qualify for what he is seeking. He cannot find anyone who is good enough for him and basically is self absorbed.

Upfront Confrontational type:

This type is the one who tells his mate upfront that he has no intentions of marrying her. He will indicate that he is just seeking friendship. He makes no pretenses. He is honest enough that he promises nothing and expects nothing in return.

Compromiser or the Victorious type:

He knows who he is and he knows what he wants out of life. He is either happily married or seeking his queen. He is marriage minded and loves the Lord and lives a Christian life. He is hard working and it turns out that he is a good man and is an excellent catch. He is victorious is every way.

The female type:

a. Goal digger type

b. Mothering type- nurturing

c. The strong independent type

d. The hopeless romantic type e

e. The confrontational upfront type.

f. The victorious queen type

The gold digger type:

Unfortunately, this type of lady is mainly focused on a husband who is financially successful. She only dates wealthy men and concerns herself with the riches and qualities that his finances can bring her in the relationship. She is mainly interested in what he can offer her.

The Mothering type:

She would be considered a controlling type. Her primary focus is however honest and from the heart but she is seeking a little boy so that she can mother him and control the relationship. Living with her will require him to pretty much obey her rules.

The strong independent type:

This encompasses women who are strong and independent and do not expect financial assistance from him or anyone else. She comes and goes as she pleases, as in being her own boss; she basically, has her own financial plan together. Some men find

it intimating to have this type of lady in their lives where she is making more money than him.

The hopeless romantic type:

This one is where she is the hopeless romantic and depends on her mate to handle all affairs for her. She is highly motivated with sensuality and matters that deal with intimacy. She is removed from the cares of the relationship and places her confidence in her partner.

The confrontational type:

She lays down the laws and she also has her life together and knows what she wants and what she will not put up with. She is most likely to dictate to her male partner the rules at the beginning of the relationship rather than wait until later to see what happens. Her tolerance is low for failure. She will essentially, lay down the laws and expect him to respect her. Unfortunately, she could run the risk of running her man off by being too powerful.

The victorious queen type:

This lady knows who she is and knows what she wants out of life. She has her own and seeks a partner who has his own; together they can excel in becoming very successful as a team. She thrives for passion and gives it in return. She can intellectually stimulate him and knows how to treat her man. She would be an asset to any man.

In the first and second Chapters we will be investigating issues such as; choosing the right partner and deciding whether you

should commit into your current relationship. We will extensively use *discovery* to confirm whether your current or future partner is right for you.

You can approach this method with the attitude that you are to give into the relationship and not concerning yourselves with what you can get out of it. You will be concerning yourself with your partner's likes and dislikes and discussing issues such as: What makes them happy? Then we will move on to some very interesting biblical revelations.

The first section of this chapter relates to the ladies relationship issues primarily. The question is: *Why hasn't he committed himself to you? Why has he allowed us to fall in love if there is no commitment?*

There are only two concerns that we will be investigating in your search to finding commitment. First: Finding out if the problem stems from him, or is the problem caused by her shortcomings? There could be unresolved issues with him that have nothing to do with her! This could be a case of him being his own enemy being manifested; preventing him from committing. Locating the problem allows you to address what is obviously a type of suppression within his own manhood which always relates to something that reverts back to his childhood.

Discovering the problem will be your next defining step. The illusion of having missed the mark, meaning he is missing the tools that are necessary to take him into a more meaningful level that will allow him to commit. In your search, let us take a closer

look at the problem to see if there is an issue he has with you. Unfortunately, you could be faced with the possibly that *you* are failing in some significant area and he is not pleased with your results?

As you are reflecting back over the past experiences in your relationship, think back in the earlier days of your relationship to see if you can recall times where he made requests of you to make changes or stop some annoying bad habit that you might have? Did you ignore him or his request? If so, he will find that to be offensive depending on the magnitude of your offense, he could be left with the feeling that he is unable to deal with your issues. It could be that there is something negative that you were doing causing him to be uncomfortable. If so, you will need to reverse the offense, in order to make good with him regardless of how small or large, you have an obligation to not be offensive.

His fear traits as it relates to you can create a problem for both of you. Regardless, of whether it is your short coming or his short coming; there is a break down in the area of communications, leading you both into a state of *confusion.*

The question is why can't he commit to her? What seems to be the problem that is blocking marriage? Regardless to the reason, this brings forward a red flag, be cautious of your unresolved issues. They are detrimental and become liabilities. However, if you initially cover them up and ignore them thinking they will just go away they will come back to haunt you.

If the answer is *no* he has not complained about your bad

habits; we will continue to investigate to discover the problem. If there is a history of him being a fault finder and he persistently complains to you about virtually everything you do obviously, your personality types are clashing. This is a clear indication that you are not in harmony with one another. However, if he is nagging away at you about your bad habits it is urgent that you reverse your offense and reach a consensus.

A consensus is having the ability to act upon an issue that you do not agree with but yet you are willing to compromise.

Please note: If you are required to change your personality or to drastically compromise to get along with him you could possibly regret having chosen him as your lifetime partner. Your relationship deserves the luxury of being relaxed and being able to be yourself, while you are at liberty to enjoy being compatible. He has to bring confirmation to himself that you are worthy of him as well as you feeling total and fulfilled with him.

Secondly, if you are finding that the problem stems from him, unless he seeks help and resolves his issues, it could be that he is not right for you. At this point, you will have a choice of continuing to argue and worry or determine that this partner that is not right and you. Unfortunately, you may need to search for a new partner.

Key to success:

It is not just about how you are feeling but also how you are making your partner feel.

If you place emphasis on *"How can I please my partner?"*

rather than going into your relationship with self indulgence, it will lend better results. Approaching relationships with the attitude of how you can benefit from it just will not work. You must both be on one accord and striving to find ways to give into the relationship. *You cannot be in competition with one another.*

Communication is key: Setting aside time to talk things over to express your likes and your dislikes as well as sharing your love and appreciation for each other strengthens your relationship and offers such wonderful rewards, as well as leads to solving many problems. It is not about how you are running the race, but how you finish. Whenever one chooses to dominate or rule over another individual, this is an example of an inadequate means to relate to your partner. In conjunction you should never designate your body using intimacy as a tool to use against or punish your partner. Far too many times it is out of your own selfish acts, that you become your own worst enemies.

What good is it to pour your hard work, effort, time, money and emotions into your relationship only to allow it to fail? Your major motive in your relationship is to invest in it and assure and insure yourself that it will not fail. It is one of your greatest investments.

It is to your advantage to monopolize all your options and give it your best and see if your end results will carry you to your victory. Note: People do not change themselves they people change their actions. Relationships are primarily made up of compromise and making the decision to go into it with the *giving mode.* Giving and sharing are two main ingredients that

will be incorporated so that once you are ready and have those components rehearsed and understood you can use them as tools in the building of your relationship and have the fulfillment of a quality relationship.

You may be required to give up a portion of the single lifestyle that creates negativities that get in the way of you achieving your happiness as a couple. Letting go of single ways of thinking should not be that important any longer. There are many cases where one mate refuses to let go of the single lifestyle along with the single friends that pose a threat; who your partner feels carries that *single's danger signs*. If your lifestyle is mimicking that of a single person and your partner has a problem with it, then I would suggest that behavior be re arranged to coincide with what is compatible for the both of you. This is also true for friends that encourage non-monogamous behavior. Strategically, this notion of letting go of *the single buddies* is only recommended if the single friends are causing a problem for your mate. In that case, it would be recommended that you let them go. That old relationship with the single life is not worth holding on to if it causes a disturbance for your partner.

Now that you are a unit or about to become a unit, the single buddy syndrome could teeter on that thin line between love and hate. In some cases, on the other hand, there are some very happy couples who managed to hold on to their old single buddies where everybody becomes friends and it works out to be a great blessing for all.

Compromise off balance Warning:

There could be those times where you are finding that you are having to compromise daily and it seems that your life is just one big compromise and you are having to constantly ignore your partner, finding that you are bending backwards to make it work, that type of matching of the two will make happiness and success virtually impossible. The personality types just don't match. If it doesn't fit don't force it!

There is a golden rule that all must follow however, there is no such thing as a perfect relationship because people are not perfect. No one should expect the two of you to be on one accord with perfect communications being on the same wave length all the time. That would be virtually impossible. Expect and allow for errors, pick and choose your battles while being mindful that they can be reduced minimized and kept under submission to God.

There is a male friend from childhood, who once informed me that men basically do not have the capacity to follow a ladies lead as (*so when dancing.*) It will take him out of his character. The male is appointed to always lead. In addition, he warns that men are natural leaders and are born warriors, therefore taking the leadership is what they are Spiritually designed by your omnipotent God to do.

Anything outside the designed format is out of order and will throw him off balance and cause him to be taken out of his comfort zone and true purpose in life. Therefore, women must line their expectations up with this reality. Always remember to be a lady regardless of how your man acts and allow him to be a man. Your responsibility is to please your Godly Father first then your mate.

When order is correct, everybody will automatically be happier because you are keeping with God's main designated plan.

It would be wise to find the hero that is hiding in him. Consequently, one must never try to change the other person. Your personality is uniquely personalized expressly for you.

Biblical order has been granted to you; there is a designated path you are assigned to follow.

Your trial time will be your dating time and engagement time if it comes to that, during that time you are to use that time investigating and deciding if that person is someone of which you are compatible.

Key:

Never appear to be in lack knowing God is your source you are a Kingdom kid therefore, you must live the part and look the part clearly if you like the part you will automatically look the part they go together.

If you are going through major transition in the dating stages, that is exactly what it will be once you get married even more intensified. No one deserves to force himself to come out of his normal being; to accommodate a non-compatible personality type. When that happens it causes grounds for war. When one is continuously brought out of their comfort zone to accommodate another person repeatedly, that will consequently trigger a mechanism that will erupt the body sending out messages and those negative traits will begin to manifest unrest, anger, jealousy and fear. *Fear,* if left unattended for long lengths of time or if it

continues to re-occur has a high risk of causing health problems, or even a mental break down for you or your partner. Avoid playing with your emotions.

Honesty brings infinite gratification into ones life and always trumps; over game playing when one is dispersing too much control by *needing to have it their way* and not allowing compromise. This will result in a toxic relationship. There has to be a balance for harmony along with love and nurturing with partner.

Consequently, by using your love tactic it is a known fact that **love always conquers hate** just as good over powers bad. Psychological damages will come out of a corrupted relationship, there has to be a balance of love to neutralize the negative.

What are some of the traits that would be considered wrong doing, you might ask? According the King James Version and the New International Version of the Holy Bible, we are taught many supporting Scriptures that teaches exactly what we have to do; *it is an abomination and a sin to fornicate.*

It is important that you read all the Scriptures so that you can get a full revelation of what you are expected to know and follow through with your actions.

The Book of Corinthians 6th Chapter:

Using this passage offers a great reference regarding how you should conduct your behavior, we are taught that we should not have sexual relationships until we are married.

My Pastor who has been a great leader clearly enunciates the Biblical meaning of fornication and in accordance to every sermon I have heard on the subject for many years the theory has a blanket affect among the Ministers; they are all in agreement and support this theory that Biblically speaking; one must have a marriage license before you are allowed to sleep with your partner intimately.

For the unbeliever:

The purpose of the two of you being together in an intimate way is to strive for that articulated marriage. Marriage is not to be taken lightly, it is for better or worse until death parts you.

Marriage is a very serious commitment a significant objective is that marriage is not for the selfish there is an outstanding degree of *'give'* that will be mandatory with the quality of a good marriage and family institution we find life becoming meaningful the marriage institution is a blessing from God and not intended to be abused.

Biblically speaking, it is ordained that the male partner is to be the leader that is not to say that to be taken out of context. It is amazing that fornication is the taboo word among the un-saved group of people and not to be spoken too loudly that is the opposite of what God expects from us.

The word *fornicate* should be used frequently and with ease it is a very important quest from Gods' point of view. There is one order that one must use; as it relates to being a single where serious intimacies are occurring. When this happens, the male should have the Christian fortitude and intelligence to make the final decision after he has heard what she has to say about your

transition. It is out of order for the female to carry the weight and burdens of the dominant order of the decision making process.

The male is designed physically to have the biceps and triceps that are muscular bound that are designed to carry the physical strength he has broader shoulders to carry the burdens of life, he is to be equipped to be the dominate burden carrier and the one to delegate the weight of decision making in the relationship so that the lady does not have to be burdened down with the weight of decisions.

Generations ago, it was traditional for the men to carry the financial burdens and allow the female to stay at home and care for the home and the children; many grandmothers who stayed at home made hand made quilts and canned fruits and vegetables and made preserves and cooked everyday. In reality however, women have had to be strong they have been the back bone of the relationship.

I am not suggesting that women are designed to play the role of being weak but I am implying that she has a soft nature that should be recognized and handled with softness and understanding.

Many of you remember that old nursery rhyme that says: Girls are made of sugar and spice and everything nice and the boys are made of snails, nails and puppy dog tail. That saying might be grossly over stated but the point intended, is that there is a respectable difference in the roles. Men and women do not have the same roles in life. Men are built physically and designed

differently and there are distinct roles that are to be played out. Those roles are in accordance to the Biblical rules.

In this century, women are failing in the area of submitting and allow their husbands to become the empowered leaders, it would actually be to the ladies advantage to slow it down and allow your man to take the lead and allow yourself to get some much needed rest. Women of today, the new age are stressed and mentally exalted and exhausted they are basically lacking in the feminism of being pampered and being spoiled with softness and kindness although, she deserves to have these things she has had to make due with life as it is; admitting at times that life can be a challenge.

Remember you are establishing your monarchy a format of being Kingdom minded.

I am reminded of another old saying that the men should *wear the pants*. I find it comical that while the male is wearing the pants; the female most often times will lay out the pair of pants he is are going to wear.

In this Book we are going across the board with Christian solutions to your problems. The word of God tells us that *There are no problems that are too big for God* he has seen your problem before you were born he knew your name already. Your life was pre destined before you were born.

Forgiveness is your emotional tool for finding love and giving love; it will be impossible to love without using the tools that allow you to become forgiving; if you ladies have put your men into the dog house, let him out because he is not perfect, neither

are you, if God hadn't forgiven you would not be here; you are now serving a forgiving God who lives in you, this is a new beginning a new day for you all so let's get happy!

God *corporately* blesses us, have you ever noticed while you were listening to a sermon, it appeared to be speaking directly to you? *God was actually speaking directly to you* and it was not coincidental. God says in his word that he *will meet you* when we are at the right people at the right places.

Women have been conditioned and forced in many cases, to carry the lead; in conjunction with having to be, both the mother and father, in the absence of the male, who does not live in the home, she has been instrumental in carrying the weight of the family; for generations. She has filled in where the male counterpart has been absent, his absence has been justified for many reasons, we will be looking at some of those reasons why this happens coming up.

As mentioned, it is against the Biblical rules for a man to subject himself to the unnatural reverse domination, where he is following the woman's lead and causing her to dominate over him, creating a situation where she is solely making the final decisions and basically, called on to rule over him. In other words, being a hen pecked man. That is not what women prefer; rather they want a man to be macho and a man. Neither is it in order for the male to dominate the female outside his Godly rules.

This will alleviate some of the difficulties within these times

we are currently living. So let us go forward in the evaluations of your Pros and Cons.

A key:

In Today's society it is apparent that women are independent and strong in their own convictions, they have their own professions, degrees and they wear their own pants.

Times have changed, this is the results that comes out of the high percentage of relationships, and rightfully so, women and men both have their needs. There is an extremely high percentage rate of bad relationships that are found in tremendously high rates of divorces in our society that are resulting from women and men who testify that their needs are not being addressed by their partners.

No one has conquered all the interjection of issues totally; it is a continuous struggle whenever you allow yourself to comprehend and teach; to pass what you have accomplished on the next person sharing in the victorious life and marriage relationship; know that God has designed you to be intra- dependent on one another in his world. You are uniquely designed and ordered by God, that you are to *love and to multiply to love one another as Christ loved the Church.*

God placed Adam to be with Eve as her husband, his intention for man is to be the husband over the woman, not to be confused, there is no mention in the Bible that informs that the female is to be controlled or mortally abused nor does she have to obey his every desire, not to over simplify, he is to care for her by

using sound Christian decisions that place second to God in his life. She needs to be fulfilled in a way that will glorify God.

A good example of a man:

One who takes care of his responsibilities to assure that his wife is *loved, cared for, protected, secured* in all ways including in your financial matters and her practical basic needs are met.

He is to *cover his wife* as well; the male leader is to take care of his manly duties to his wife, which will have a revolving return that benefits him as well as benefiting her and to the family institution. The phrase *"cover the woman"* means there are roles for each partner, he is physically built as the stronger partner and he has the role of covering or protecting her.

According to modern Ministries, it is believed that the male partner should be solely responsible to take care of the finances; the female is to offer her support to him as his helper. The male carries the leadership in the unit of marriage; this area in itself is where many of you have gotten off course.

It would be advantageous to say don't feel bad if you have fallen short in this area; it is a very delicate sensitive area being totally obedient to your spouses or even to your potential partner.

A lady once complained that it is virtually impossible to follow a "parked care" she added that if she followed her husbands' lead they wouldn't get anywhere; that would be rather difficult and that could leave one a lot to be desired in that situation.

For the Ladies:

This is an example, why the need to choose or be chosen is expeditious and requires a great deal of good judgment and intelligence.

Your focus will carry many facets; one major concern will be to focus on finding a partner who will allow you to grow and be yourself being relaxed not having to be stressed or stretched about the cares of the relationship. Being equally yoked is imperative and will add to your assets in your search to finding a loving relationship.

In addition, you will be investigating to see if you have the ability to meet your partner's needs. We will discuss those needs coming up. This is a top priority as it relates to your relational fulfillment.

There is a relationship order *from the word of God* that has to be followed.

Ephesians 5:16-3 2

"Wives submit yourself to your own husbands" as to the Lord *for the husband is the head of the wife as Christ is the head of the Church husbands "love your wives."*

Now as the Church submits to Christ, so also wives should submit to their husbands, in everything however, each one of you also must love his wife and he loves himself and the wife must respect her husband.

Rev 22:7

Behold I am coming soon! Blessed is he who keeps the words of

this prophet in this Book. His Book is the only guide that can give you your assurance there is nothing else of which we can anchor ourselves.

*Your attitude will determine your altitude whether you soar with the eagles or just let go and cave in is determined in your attitude. Jeremiah 29 vs. 5-7

Gods says we are to: *build houses and settle down plant gardens and eat what you produce, marry and have sons and daughters, find wives for your sons and give your daughters in marriage so that they too have sons and daughters.*

It is suggested that you no longer just sit and deplete, you should marry, increase, sell, build and grow. One must learn to take his ability to give to its highest denominator the art of your giving is your gift from God. Couples must learn the art of Giving.

Luke 4:18 and Luke 8-11-18

Another favorite scripture:

Key:

*"You reap what you sow "*If you are selfish and serving an un giving Spirit you will reap from that un fulfilling selfish harvest which will ultimately choke your blessings and corrupt your relationship in due season.

The Holy Bible teaches that you are to encourage one another daily, encourage regardless to whether or not it is deserved, encourage everyday, *for it is better to give than to receive.*

Scriptures are self explanatory, the acting Judge teaches it is through your giving that you receive, the more you give the more you will receive from God. When achieving a balance in your relationship, with the attitude of gratitude being thankful for each other. Be thankful that you have a partner or when you get one never taking them for granted. Living alone has it's advantages as well as its disadvantages. In the Book of Corinthians: *God says: that two are better than one if one should fall the other will be there to pick him up.*

The word of God is your greatest seed!

A Key:

It is through placing their need before yours that will bring you success and a victorious myrmidon.

KEY:

The Marriage institution gives way to adding a significant meaning to ones life and should be sanctioned by an Ordained Minister upon the wedding date.

Identifying your Pro's and Con's is a process where you investigate to find your partners assets and their liabilities. Finding out all you can in regards to your likes and dislikes about your life's partner. This book recommends that you list your Pro's and Con's, making a mental and physical list of what your partner brings to the table. List things you are enjoying about your partner, as well as what you do not like about your partner.

Excel in that area, that is to say; I am enjoying my partner

because he makes me laugh or maybe, he has a kind heart or maybe he has a high income or loves to have fun, whatever it might be that draws you to him would be considered as you Pro's the positive attributes.

List the negatives: The Cons where you will find the contraries.

When evaluation Con's as we are taking a closer look it is best to identify your partner's negatives that exist; the things you would rather not have to deal with however they are no doubt there and not leaving. List those things it is better to find out before the marriage rather than to have regrets later on.

For example:

If he is sloppy and throws his clothes around, or maybe he goes out with the boys, without you on Saturday nights; or he could be a poor money manager, whatever the negatives you are finding happens to be, the purpose of this pre-marital testing, will be to allow you to investigate; by using the positive traits as opposed to the negative traits; to measure your differences, as you are discovering the adversities.

Another example:

If you are a lady who enjoys shopping on the weekends and you find relaxation and pleasures from going into a vast variety of Shopping Malls and there are times that your shopping is time consuming and you do not intend to change this order; it would be best for you to find a partner who is not watching the clock when you are away. If you are finding that your partner

the jealous type who gets upset with your time being spent on shopping; you might want to consider that situation as carrying a *red flag* and the advice would be to proceed with caution.

These examples may seem as pointless issues, but they could escalate into bigger issues as they are played out in reality.

When listing the Pro's against the Con's you might want to check is to see if you will be able to come out on the winning side. By means of investigating areas where you will be finding *credibility* as opposed to what will deviate and take away from the relationship.

You should have good and judicious reasoning as why you have chosen that partner?

There is no such thing as a perfect relationship all couples will have some degree of crisis; you are going put up with some things you will not agree with. You will have to occasionally reach a consensus where you will have to find ways to agree even if you don't agree with the issues.

It would be nice if one could have it their way all of the time but that is virtually impossible, having that perfect little situation in your marriage that was made in Heaven; in reality there will be trials and tribulations.

This key is to overcome the obstacles.

Let us now go further into our investigations to see how we can better become over comers.

In your *Spirit being;* allow yourself to get above and beyond

the flesh as Christians. God is always in your midst and he will take you to a higher ground through his process of renewing your mind. God has the power and speaks out about this *transforming of your mind*. He can take you from being frustrated and sick and bring you healing. God anoints and lifts you over your crisis.

You can and you will become victorious over that haunting negative situation in your life; know that it is your mind that controls your emotions, your feelings, and how you sort through your issues in your life. Your mind is one essential element that can control your pain and even has the power to control your healing. That is why you are praying for God's *transformation of your mind; or soul; they have the same meaning*. Your negative issues may still be there no doubt, but you won't have the desire to struggle with them any longer. They will no longer affect you.

If you have decided to stay in your relationship because of what you have invested into it and do not intend to bail out at this time and you have decided that walking out is a form of weakness, there are ways to entrap your future's happiness and find fulfillment in your present circumstance.

Being an author who is also the Mother of a Successful Female Texas Attorney I have found that in the Family Law office we are seeing far too many divorce cases that are in conjunction with the rising crime rates on the streets.

The dismissal of the male leadership is gravely at fault

In this Book, we will investigate the causes for the break

ups in the relationships and find out why couples are becoming unfaithful to each other.

Let us take a look at what the Holy Bible has to say about *How you are to Handle your Relationship.*

It is a difficult task anytime there are two people interacting on a daily basis expecting to relate and compromise with each other; there are many times where you will have to relate, spiritually, socially, emotionally, intimately and intellectually the outcome from this will bring a wide range of responses that stems from sheer blissfulness to a sorrowful breakup. Even with the best of marriages, there will be issues.

We are taking a closer look as issues such as: Checking your awareness, and discussing your spending habits and issues such as how well you inter relate with your partner's family and much more. *There is a quiz for you to rate yourselves and exchange your thoughts.*

A word of wisdom:

In the process of taking charge over your own life, you will never allow another person tell you that you are not worthy of receiving your God's Blessings you are worthy; to enable you to receive your sense of worthiness, it will take your ability to allow the Spirit of God to enter into your Spiritual realm, to fully absorb your God given Blessings.

Listed are some ways that you can help to over come life's obstacles, there will be struggles as you are in the battle of your life.

The ladies are curious when it comes to the issue of what

makes men happy and they want to know more about it. As for you, the reader, having a female author offers an additional beneficial, if you want to know about a female ask another female. To help the guys understand what the ladies are expecting from you. If you are going to be with a female it would be wise for you to study them and find out their make up. Search for things such as what makes her happy as opposed to what makes her unhappy. There are very interesting revelations that are about to be revealed to you.

For the male reader:

When I ponder over this issue it brings me to a Sermon I heard from my Pastor; in his passage he announced to his congregation: "*Do not fall in love while dating a person who is* not *willing to marry you.*" After evaluating that statement, I clearly agree with it. Why? Because emotions and feelings that are intensified out of spending time together, as a couple you are interacting and becoming best friends it is natural that you will at some point began to have those emotionally longings to spend more time with that person then the obvious happens.

There are cases where the male is not willing to marry his partner and visa versa but more prevalent with the male. He chooses to remain single, however, while he is enjoying his male singlehood life and all the joy that being single brings him he attaches her to his life when he is in need of a female to fill that void, when needed, therefore, after she has fulfilled that need in him he can return to his domain and flee the responsibilities of

being committed or married. A familiar type of shunning away from marriage.

Example:

I have a friend who chooses to stay single although, he is dating regularly he is not seeking a serious relationship or marriage. He is however, looking for love. This guy is really unique, (*there will be several types of personalities mentioned.*) I found that what he wants is someone who can match his finances. Although, he has no intentions of marrying he still wants her to be top shelf. He spent most of his life saving his money and working to finally buying his dream home, he lives alone and loves it that way; suddenly his desire for the regular girl on his street type has diminished.

That type of rational thinking on one hand is understandable that you would want someone who is equally matched financially however that philosophy carries a thin line and could classify him as a Gold digger. Money will not make you happy. In fact, I am hearing from millionaires that the more money the more stress comes with it. *The love of money is the root of all evil.*

This single lifestyle allows him to have his cake and eat it too. He is now enjoying the best of both worlds.

He merely finds a lady who can bring him the desires of his life. However, he is not in tuned with her emotional attachments with him, he is not in touch with what is best for the both of them, as a couple he is consumed with what is best for him for the moment; and he has failed to outwardly scope out a long range

thinking process that allows him to see her side and what is best for them as a couple as he is places his focus on material things.

This scenario could define him as being narrow minded and looking at the wrong picture. *It is about finding a love.*

The danger with his being non committable is that unless they are both guarding their hearts on a continual basis one or both of them is likely to fall in love, leaving the scare of fornicating to enter into their relationship.

It is highly recommended in this *book* that you seek a committed relationship if there is intimacy, after a reasonable length of time, assuming you both agree to stay together. There is a significant difference between being friends becoming lovers. With an agreement that you are just to be friends there is no demand or a need for you to commit for marriage if both intentions are to just be friends.

For the lovers, let me suggest there should be a time set to take the responsibility for your actions. A good place to start thinking commitment would be approximately in 3 to 6 months into the relationship, although, couples work at different paces, there has to be rules and discipline in the area of timing. Timing is everything; needless to say, couples work a variable speeds setting this time frame is just an example, so that you are making some kind of progress.

A well known relationship authority suggests, that the male should have that talk with the female after approximately the 3rd or 4th date, you should have the capacity to know by then if she

is someone you wish to investigate as being someone you wish to share a life long experience with, of if she is simply someone you wish to share only a friendship.

Tell her upfront what you are expecting out of your relationship. It is amazing that how naive the female can be in this area she sometimes hears commitment, when it is not available, she imagines marriage is coming based on the male's actions and assumes he is in love with her. You guys need to clarify your intentions to your girlfriends, especially if you do not want to marry her. If you want marriage, be specific and tell her you are seeking marriage and you are finding her to be that special lady in your life.

After you have taken enough time to get well acquainted it is look upon as being the responsibility of the male to initiate the first talk.

By simply discussing where things are and where you would like them to go; normally couples can tell at first site if that person is right for them. It shouldn't take you a lifetime to make the calculations and do the investigating that gets you to where you have the assurance that you have chosen the right partner. I actually met a lady who told me she finally got married after over 20 years of courtship. She was so proud that they finally got married; she was smiling from ear to ear and indicated that her advice was to never give up. I am sure you will agree that is an exceptionally long time to courtship. There are no free rides in your relationship.

In recent society, we are seeing a large sum of ladies who have caught on to the vision that their bodies are sacred and to give it over in un Godly acts is a violate to yourself. Women are not giving their bodies over to intimacy without commitment there is a great movement of God taking place in that area, the Churches of today are teaching abstinence and it is catching on like wild fires. One must be accountable for their actions. You will be required to have a marriage license before you are to sleep together with intimacy.

We are all needy and designed to long for intimacy, pleasures and companionship. No one escapes those emotional attachments since we are created to be intra dependent on one another, why fight it?

If you're finding her good enough to date you and she is finding enough qualities in you that she obviously enjoys and she is finding the time to date you, that is enough assurance that she is interested in you; ladies do not invest their time dating men unless they are interested in you. If she is seeking marriage, you are obviously having questions as to whether she has the qualifications that you are seeking for marriage. If she is not good enough to marry; you should leave her alone and find someone who qualifies for what you are seeking. Why stress her out with the commitment issues, once she begins to have feelings of intimacy for you?

Often times, couples tend to complicate these issues because they don't want the responsibilities for their actions; that spell immaturities, and being irresponsible for your actions. Two

responsible people who are of age, and cannot bring themselves to commit after they have acquired an emotional and intimate desire with each other, are expected to do the honorable thing and should commit to marry.

The major key would be to keep it in order.

You might ask about couples that play games? Game players are essentially, very insecure people in an articulate way, anytime you have to lie or cheat to catch up in the game of life, you will never win at that rate, games are for children as an adult you will avoid making your partner jealous that is a waste of time and could back fire on you. If you dish it out make sure you can take when it comes back to you, if handed back to you, someone is bound to get hurt while playing the games. Games are usually generated out of disappointment from past experiences.

There is an unseen sense referred to as the 6th sense that tells you in a subtle way that trouble is lurking somewhere in your relationship. You should pay close attention to it. Once that happens you might want to sit down with your partner so that together you can exchange those alarming negative issues that have been no doubt become irritating and building up; those very issues left unattended will grow into bigger issues later on.

Keys:

If you want to know about a female ask another female.

Secondly, the female is supposed to be there to help the male, not the opposite.

Sow into her; when you have a need you must sow a seed sow to the measure you want to receive. The word of God is your seed.

"Anyone who does not carry my cross and follow me will not become my disciple."

The Spirit of discipleship is still carried on we must carry the cross as long as it takes as we continue to wait on the return of Christ.

It is imperative that one learns the urgency to *"give"* daily, giving is a blessing and honor you will notice a tremendous change in your relationship once you are sowing your seed it has potential for a return.

What you sow into your relationship is what you will get out of it. Your ability to sow will determine the quality of your relationship you are held accountable as to how well you have sown into your partner you will need the knowledge of the Biblical theory of sowing and reaping in order to sow into the area of despair to finish the race successfully.

Key:

You have your returns from your sowing so that out of your obedience there is a rewarding return. When you begin receiving the returns from your reaping you will be honored, respected and you will now find fulfilled in your loving adoring relationship. You will find also you will be glorified and made acceptable before the eyes of God.

The break up of family is a major contributor for the increasing

rate of crime I are am hearing on the National news that the divorce rate is rising to approximately 60%, we are seeing divorce rates climbing in our Law office, usually once it hits the Attorney's desk, there is nothing left of the relationship it is usually the end results.

Sowing and reaping has been a major issue since the beginning of time. Using the Scripture that tells us that God is a seed; carries with is a hosts of meaningful definition. When you are thinking about God being a *Seed you* might also want to think about God as being the greatest giver of all times in John 3:16 a favorite Scripture, where God gave his only begotten son so that whosoever believeth in him shall not perish but have everlasting life. No one can out give our precious Lord and Savior.

Author's Note:

Nearly everyone, no doubt, will have to deal with a relationship at one time or another. I have prayed for the readers of this book. Asking God to bless each reader and help you to resolve your relationship crisis. By the grace of God, he has allowed me to present this book to you to help you sort out those relationship issues. Through the goodness of God this Book is intended to promote love. The lack of love is a root cause under scoring most of life's problems. There is a path that will lead you into the arena of loving again. There are hidden secrets in your Bible, they are hidden so that out of your obedience they will be revealed to you. When you are spending time in the Word of God, those secrets will be revealed at which time allowing you to move in that direction so you can claim your portion of love.

God will take that injured place where you suffered the most, your biggest mistake, the area where you fell down and thought you would never get up again to use as your testimony to tell the world how he healed you. He wants to get the glory out of that testimony.

Designed to promote Love:

Remember, life has it's difficulties, there will be the illusion of trials and tribulations, you will experiences them from time to time however, you must never feel defeated never give up, in your due season God will answer your prayers. It will take time.

Now we can take a look at what is meant by investigating your partners' Pro's and Con's.

Chapter Two Investigating your Pros and Cons

In receiving the infinite Revelation of God and what he has in store for you. God's glory will be a continuous process with small doses at a time, if he put his fullness of Glory on you, it would be too much for you to contain. You are required to just hold on by faith never cave in and don't let go. *By faith God will see you through.*

In this Chapter, we will determine if who you have chosen the right partner for yourself; by looking at ways you can investigate; with the results bringing compatibilities that confirm a good and wholesome choice that will bring you good results.

This summary consists of two topics that we are addressing, that will be to investigate their good traits that carry the qualities that you prefer, as well as the bad ones traits that you do not

prefer, as you are getting focused on how you will handle those traits you are finding.

There is list the do's and the do not's.

Astoundingly, there are adult individuals that do not know the proper allocation of the do not's and they grossly misunderstanding the differences between the two. There should be no doubt that there is a unique difference between the two.

There are clearly rules that must be designated, you are in a crisis when you are not doing what it will takes to find your victory.

For those of us who want to advance to getting it right not to just get by but getting good quality over tones and inner qualities from our efforts. Using the Biblical and righteous method allows one to reap from that harvest during harvest time in your relationship. In your receiving mode, is where will find your benefits from your right way of thinking. You are about to engage into viewing ways that you can *"Handle your Relationship"* to get to the finish line and see the quality of life that you have been striving for in a timely fashion.

Galatians 5:22

The fruit of the Spirit is love, joy, peace, patience, kindness, goodness, faithfulness, gentleness and self control, against such things. There is one Law.

Key: The Word of God is your seed.

Sowing his word is what we are instructed to do therefore,

you also must sow into others. By sowing into the world you are carrying your portion of his cross.

What are ways that me as the male leader can make improvements.

I will list the things that will improve as well as destroy my relationship.

For the males: *Pros.*

I will touch her at least one time each day, as I am learning to love her, I will tell her I love her as often as possible.

I will set aside time for the two of us to talk and get better acquainted

I will remember to put her needs before mine.

Listings of Pros

For the male:

This list is to help you identify with what it will take for her to be satisfied with you.

I will take care of my financial obligations to her

I will spend adequate time in my prayer along with enhancing my Bible study time.

I will keep my temper under control and will work diligently at bringing intimacy and fulfillment to my wife.

If you are single, I will make the right decisions that will lead to marriage in a timely manner

I will love her

I will not cheat on her

I will not leave her at home while I go out to play with the fellows

I will not drink to get drunk nor use illegal drug

I will allow her to know my whereabouts when I am away

I will not fight with her or use profanity

I will keep my appearance neat

I will not you excessive distractions from her

I will include her in my financial decisions

I will include her in my free time

I will help her around the house and with the children

This is a summary of areas for change

For the ladies: *Pro's*

This list is to help you identify what his needs

I will allow you to lead me

I will listen to your criticisms

I will keep my spending in line

I will submit and enjoy my intimate experiences

I will not allow outsiders to interfere

I will take care of my responsibilities as his helper

I will keep my appearance up

I will continue to grow spiritually

I will find ways to intelligently communicate

I will participate in the life style that pleases him

I will learn not to be selfish

I will place his needs in front of my own

I will commit to changing

I will no longer argue with his decision

I will not deny my body to my husband

I will no longer serve him with fast unhealthy foods

I will never neglect my time with him

I understand that I cannot neglect the home nor it's cleanliness

I will not disrespect him

I will not use intimacy as punishment or rewards

I will not neglect my appearance

I will no longer ignore my responsibilities to grow

I am to spend time in practicing and applying the Word of God.

When the male partner takes the initiative to fulfill his obligation to her, you will find that encompasses those perplexing

issues begin to take a turn. It is the simple things in life that encompasses your major recoveries.

Touching carries an abundance of healing power with it physical touching will add a new dimension to the stimulation process touching gives pleasure. It is a method that works so that when you begin this process of touching your partner regularly, as you are incorporating love into your daily living, however, touching is secondary to the pleasures that your Spirit will embrace.

Adopting the ultimate pleasures of touching each day will bring a noticeable response to you. There is a unique expression when read; where another Book author describes men as having the nature of a micro wave oven as opposed to the female who is more like the crock pot, that is a great expression and so true; that should tell you that there is a need to compromise to bridge the gap.

It is not a mystery that females take longer with getting dressed and prepared mainly because they have more details to cope with than men. Women basically, are concerned and compelled to give him her ultimate beauty since the female glorifies the male her appearance is very important to her that in itself is time consuming.

Key:

We are so busy in life that sometimes, the things that really matter get over looked. Setting time aside is imperative and key' it will require scheduling an appointed time to do activities

together, perhaps a couple of hours each week even if it is the simple things such as going to a movie.

Those small enduring moments carry big rewards.

Once you are married or if you have been married for many years, never stop dating hold on to that very thing that brought you together in the first place, what is it that you were attracted to that very thing is all you have to dwell on, once you are growing older together always give of yourself to her shower your lady with compliments.

It is quite astounding that women love and admire being complimented. Ladies adore being told that they are beautiful and thin, even if she is severely over weight, they love to hear it from you those spoken words *"I love you"* you will have her wrapped around your finger.

She is somewhat exploited by her emotions. She has that small area of insecurity that needs to be fed and nourished she wants to hear it.

On a daily basis, tell her that you love her; '*I love you*" are those words spoken that will win her over every time; in addition when you compliment her on her beauty, her intellect, her dedication and tell her those things you admire about her. It is imperative that you are placing her needs before your this one will guarantee you will make a home run, there is no doubt about it.

In making an assessment,; some of the definitions of ways to give and how significant it will be to give, you should know anytime you give, rather than to receive you will benefit by placing

her needs first, not only are you obeying your Bible. And you are setting the stage for a very loving and fulfilling life together.

Bible Scripture that clearly tells you that:

Key: *"It is better to give than to receive"*

There will be some incredible occasions where the two of you will not agree. When that happens, as her leader; and her male counterpart; you will need to have the capacity to allow her to have it her way. When it is a matter of something that is immaterial, not to suggest that you yield to her way, always, however, the petty issues will be something that you can ignore. Suggesting that you engaging, so that there will not be negative provocation from her; as a result of your poor leadership. You are striving for a peaceful flowing of togetherness in a positive manner.

This might sound like an easy task however, there will be multitudes of repeatedly times that you will need to know how to compromise with her there will be those time where you disagree; disagreements can be easily solved, if you are indeed the man and you will need to step up to the plate.

There are few social affairs that are not expensive you will need to get your finances together; being financially secured is a necessity; not having to become wealthy, but being in a substantial position to meet most of her financial needs.

The rate of unfaithful relationships between men, as opposed to women, is approximately two to one men are prone to retaliate with pre marital relationships as a means to empower himself.

One of the major reason men cheat is because they have an incredible craving for someone who knows how to makes him feel good about himself. It is seldom all about the intimacy.

He is trying to apply a new dimension of self worth to himself in his new relationship he looks for his restitution and a sense of being more respected as he tries to find his salvation the two major reasons for unfaithfulness are over money and cheating or getting caught during the infidelity act.

Investigating your Pro's and Con's.

Finding assurance that you have a fighting change.

There are significant ways of telling that there is unfaithfulness.

This is a summary of unfaithfulness issues:

There are ways of distinguishing infidelity. Here are some examples: *Con's*

He begins to come home late suddenly

His attitude changes he becomes irritable

Loses interest in lovemaking

Lipstick on his collar

Appears to be nervous or his demeanor changes

Erases the call I.D. or phone call hang ups begin to happen

How comes up with gifts from an unknown source or unexplained spending

He has a scent that is differently; like her cologne

He has that unexpected emergency this out of town

He spruces up his appearance

He suddenly begins to focus on his appearance

He is trying out a new hair do

He buys a new sports car.

The cheating female will find ways to cheat, however, during her cheating memoir, she confesses it was an end result after she has lost her patience frustrated and failing to get things in order she now feels that she is exasperated and has exhaled all of her resources. Statistically her rate of infidelity is much lower, a bit less than half the rate of men because women are generally reserved and very select with whom they choose to get involved romantically.

Women are geared to concerns of her reputation and how she looks to others.

a. She will take that trip out of town with that girlfriend.

b. She will do lunch in the afternoon.

c. Another indication of her infidelity is that she loses interest in her intimacy with her husband.

It will be virtually impossible for either partner to maintain a

good relationship with both the wife along with his mistress the tale tale signs will be showing up at some stage of this game.

Women tend to have an invisible antenna claiming to have female intuition described as having the capacity to sense that little inner voice that tells them there is infidelity going on. If you find that there is unfaithfulness, your anger should be focused on your partner and not to the other infidel. It would not be wise to place your anger or blame onto the other party involved because there is a possibility they might not have known they were dragged into this unfaithful affair.

If your question is *how you can prevent unfaithfulness?* Rest assured if you have a cheating partner, there will be little you can do to prevent this devastation from occurring. That is the purpose for taking time to investigate your partner. Fidelity issues are real and should be discovered before marriage.

When your are in the investigation stage it would be wise to find out if there is a possibility of infidelity; to assure yourself of fidelity should be nearly impossible just use you good common sense when judging your partner's fidelity tests; by doing your part is what you can control; and by being a faithful partner you will need to do your best and take care of your responsibilities to your partner.

If you have that devastating issue of unfaithfulness to hit you after you have done your part, it should not be your burden. There is no known statistic telling you who is cheating, however, it is estimated by some divorce records that the ratio is a bit over two to one. Approximately 65% to 35%. There are non-cheaters

also, the couple who are faithful to each other. You should be able to recognize what kind of partner you have chosen as you continue your search.

There is good news.

Look to your God as your source, fear is the root cause of your problems, it is the fear trait that causes your body to lock itself down. Today is your greatest day you have to have a road map to get to your victory.

The Bible indicates, that *faith comes by hearing the Word of God,* we get our hope through faith and our evidence comes through our faith. We must be fed the word of God, either by hearing it or by studying the word.

My favorite scripture:

Proverb 3:5

Trust in the Lord with all your heart and lean not on your own understanding in all thy ways acknowledge him and he will make you way straight. God will direct you path.

So that now you can begin to plan bigger to escalate and grow.

In order to grow you have to get up and go.

1Corintiains 6:9 *Flee yourself from fornicators the Bible says* "*Know ye not that the unrighteous shall not inherit the Kingdom of God.* Although the Bible discourages the husband from divorcing his wife. *It is good for the widow and the unmarried as he is. If you cannot contain yourself it is better to marry. For it is*

better to marry than to burn. Burning with passion is not good news. Awesomely, you must begin to pay into what the Word of God is directing you to do.

The Pastor refers to your account. According to him, we are investing into our Spiritual accounts, whenever we are paying into the investments of God. When we give in our services or our money or good deeds we are making deposits into the now, as well as the here after; your Spiritual account.

When giving ones deposits it is imperative that you deposit into the care and attention to what your Spiritual Father thinks about your behavior, at all times relatively speaking, the length of time you spend dating does not necessarily define the quality of your relationship, some couples prefer to date a longer periods of time, some prefer brief encounters and find a need to rush to the alter, then there is the group of couples where neither of them are interested in marriage at all.

The length of time you are dating has little to do with the quality of your relationship however, one should set aside a minimal time to get to know your partner, some people operate on a faster pace than others.

Why rush into something hastily that is suppose to last a life time? There is no need to rush "unless one or both of you "*cannot contain yourself?*" If you cannot contain yourself there is a need to concern with your timing.

The Bible teaches it is better to stay single, unless you cannot contain yourself. To rush into intimacies before you are well

acquainted could lead to disaster, I would recommend that you avoid interacting together where provoking might occur.

Your body chemistries as a couple are designed uniquely for you. Your timing will be yours to decide the two of you will set your own rhythm or pace. And naturally your clocks will let you know when it is time to advance.

At some time in ones life, you have no doubt ran across the couple that has decided to stay together, then there are those who seem to think that marriage is not for everybody. I want to inform them that *if formicating is for you then marriage is for you,* if you are dating and serious intimacy has occurred or about to occur yes marriage is for you.

A divorce can appear to be form of death it feels like s a part of the body a limb that has been removed. Therefore, you must stay in covenant with God.

It is best to not have to go through a divorce, if you have ever experienced, it you will agree that it is not a pretty situation.

Therefore, how you handle things is key; keeping the main things the main thing and doing it properly in the early stages. Guarantee yourself that you will have a victorious relationship people marry for a number of reasons mainly, because they are in love and because they yearn for each other's companionship they wish to sanction their intimacy.

There are couples who have chosen to stay single. Not finding marriage appealing to them. They do not want to lose their single life. That couple who lives together has chosen that life style for

economical reasons to save money or for whatever their reason might be. This is their alternative route for finding their fulfillment.

They are in love and find that marriage is a threat to their happiness finding marriage is too confining, or they love their partner but can't tolerate their manners, or they cannot commit to just one partner, whatever the reason, it seems to work out for them it is their agreement and many who are living together will tell you it is working out great for them.

Judge you not one to another lest you will be judged. We are not to judge one another that will be up to God.

Crisis:

There are situations in society where married couples feel they don't really know each other, there is not enough time in each day for them to spend enough time together so that they can feel a sense of being together, getting caught up with everyday scrambling and the mass of confusion with work, and the daily routines.

It is unfortunate that marriage has been redesigned to being an unraveling series of unfavorable events, rather than what it was intended to be, we have all heard married people say that they will never marry again or they regret being married, it is normal to feel that way, if it is a temporary feeling that leaves and seldom returns.

While you are trying to figure out how to resolve your relationship issues and wondering how you got into your crisis there is nothing worse in life than insisting on staying in a bad marriage. The Bible has a wonderful conception about divorce and it discourages divorce.

In recalling the Bible story about the woman who was caught in adultery; the people who lived in that village wanted to stone her for this un Godly sin of adultery however, when brought before Jesus to stone her; Jesus reply was *"He who has no sin let him cast the first stone"* The woman was set free. Jesus was making a very significant point, his intention was that we are not to judge one another, that will be his job.

The Biblically versions speak out clearly that, if you get married you are expected to work it out by being obedience and applying to the Word as your guide. Unless one of you should die or caught in infidelity, there is no other excuse that will bale you out once you are married. You are commanded to basically stay together for a lifetime however, it is permitted that you can always flee or separate with an abusive partner.

In relating to the teachings however, if you are suffering from an abusive marriage that causes your health to fail it is recommend that you stay away from that situation ,whether you decide to divorce or stay in the marriage. By separating you have chosen to stay married that will be a major decision for you.

It takes two to marry and if both parties are not willing to work it out there will be problems, there are divorce cases where one party wanted to marry, yet the other partner was apprehensive and had to be coaxed into it. Physical abuse is common, the abuse comes in various forms, whether it is mental or physical, it must be taken under submission, to define abuse, would be to simply ask your partner, there you will find your answer.

There are so many forms of abuse such as: *Con's*

Not speaking

Withholding sex in marriage

Disregarding your partners feelings

Allowing outside interference

Over spending, too much shopping

Excessive drinking, drug issues

Profanity

Disrespect

Neglect

Once the both of you have established yourselves and decided to stay and fight for the relationship, it will be worth the struggle. Once you have made that decision you have chosen to stay in it, you are primarily saying yes, I want to do whatever it takes and we will win this struggle.

Communications is you best tool by keeping that door opened allows you to identify where the pain is coming from and there will be pain.

Wisdom Key:

If someone gets offended by something you did to them, it is not their fault it is your fault.

That is so significant, if you can comprehend that statement

you will obtain another degree of satisfaction. We could preach until dooms day about respecting each other but until you apply it each day it is just words being spoken.

That is why it is recommended that you go to Church; Going to Church serves a purpose for many reasons, there are always going to be the critics of Churches, those who sit back and do nothing and there are those who have legitimate concerns, the critics are negative about the ways in which the Church is appropriating their funds, this is a reality, they are in the unknown in terms of where their money is going in many cases, they only see that there is so much hunger and poverty; you should know that anytime you have a congregation of people, especially a larger group you will have that small percentage of negatives people and a small degree of negative situations will arise in all Churches.

The God I serve is a big enough God that he will take care of any and all the negatives in his Church. The Church is a place of meeting with God, to fellowship with others of faith believers enjoys the programs, sermon, the singing. The Church is a place where you can also have a one on one meeting with God, we are taught in his word that he will rebuke the devour of our seed. And it is far more important for your Spiritual growth to be there to receive God's word and to partake of the fellowship, as well as to become a part of the Ministry as mentioned in your Bible.

That is a perfect place for your children to be fed also since many times we do not have the time to teach our children and feed into their Spiritual well being; the Spirit requires stimulation and feeding just as your physical body.

When living in the world of Spirituality, it is as though we are living in a second world where we find that when we are releasing strongholds and stress from our bodies in the physical by allowing the Holy Spirit to flow, we can overcome and wash away the impurities in life and remove those obstacles that are in the way through the power of God.

Recently, I met a man who defined himself as Agnostic needless to say, I was a bit embarrassing because I didn't know what Agnostic meant, later, I was telling a lady friend about the man and according to her, as she begin to explain to me her version of Agnostic saying; when a person is Agnostics they are neutral their opinion is neither for the miracles and the Bible stories mentioned in the Bible nor against the Bible versions.

The Bible teachings and miracles that Christians believe by faith; carry no significance, with the Agnostic, they take no stand on those issues, whether it actually happened, whereas with Christian we are faith believers; we do not concern ourselves with what we cannot prove with our five senses.

The man, who was agnostic, asked me if that would be a problem for me. I answered him with honestly

The answer to him: 'As long as we are friends I have no problem with our differences. If I was married into your belief, yes it would be a problem. Since we are friends your belief as an Agnostic believer is fine with me, it is not for me to Judge your belief system."

In a relationship where one of you is a believer and other is

not, creates an unfair playing ground you are unequally yoked. I can't rationalize it working for the better. In fact, I would love to hear more about it the Agnostic faith.

The struggle in health or finances will affect your relationship. The word of God talks to you the word will spring forward when you are in a needy place in your life, strive to become fully persuaded in your walk and have no intentions of changing your faith level, it is healthy to at least hear your opposing point of view without feeling threatened.

To strengthen your body and to increase in your financial prosperity, there is a need to walk in the power of God. Never resort to becoming a lazy Christian you must act on the word.

If you are in trouble today God can help you; when you give it to him in prayer give your heart to God and give your time to God. The Devil, Satan is the oppressor, but Jesus heals and sets free. Sickness is oppression from the devil. Step out in Faith because *Faith comes by the hearing of his Word.*

Put on you oil, whatever weapon you can find, if you own a prayer shawl it is referred to as a * Talitha Cumi Shawl.

To fight against the enemy many used this shawl in prayer mostly; symbolically the Shawl has great significance, some of it's' history is related to the woman with the health issue in her body. Mark 5:26; She trusted and believed that she could press through the crowd of people surrounding Jesus, and if she could just touch his hem; she would be made free from her infirmity. The hem of his garment has great definition, she finally made her

way up to Jesus and touched his hem. Jesus spoke and said "who touched me" That woman put a demand on the word of God. Jesus told the woman her faith has made her whole and she was healed.

The Hem: is defined in Greek as the number six hundred 600. Matthew 9:20 please read it.

In a recent sermon a well known Pastor presented this interesting equation:

In Greek a tassel of twisted wool in the Praying Shawl's, there are fringes the blue tassels equal five double knots.

Each wing has eight strands In Malachi 4:2

Then you add that; it equals the number thirteen. Therefore take the six hundred add the thirteen and you get 613 which is the number of commandments in the Old Testament that Jesus fulfilled when he died on the Cross. This is an amazing observation.

The Bible teaches that Jesus went about healing all the sick in the land he will also heal you; God will also heal your relationship. ***By his stripes you are healed*** the stripes he took on the cross at Calvary when he died as your sacrifice, so that you could go free from sin. Jesus carried your sickness and your disease with him on that old rugged cross.

Let to pray:

We are believers of your word and we believe that you are with us and that you hear our prayers. We want to thank you for Christ

Jesus who died for Heavenly Father we have come to you together asking for our sins to be forgiven please forgive us for our sins.

Help us Father to become over comers help us to live obedient lives. We come to you for healing in our bodies and in our relationships please heal our bodies and our souls.

Help us Father God in our relationships to be better managers of your word.

It is our intention to please you and glorify your name please forgive us when we fall short in our praise.

Thank you Father God for all your blessings that you have given us even when we don't deserve them thank you for forgiving us of our sins help us to do better each day Father as we grow in you.

We want to pray for our families our children and for all Christians that you will have mercy on us from our past sins. Your Word says that you will forgive as far as the north is from the south and the east from the west that you will cast our sins into the sea of forgotten.

You are a great God and we love ever so much.

In Jesus name we pray.

Amen

We are saved by the Grace of God and nothing else.

1Peter 5:10 we are reading the passage that Faith without works is dead.

God knows your thoughts and your plans and he will cause them

to happen. God says he will lead you into the shining path that will take you out of the deep darkness where they don't know why they stumble, out of ignorance.

There is a fascinating female Brain Specialist, who was interviewed on the air, she was referred to the issue of 'fear' and I noted that in her monologue, she spoke, regarding the damages fear causes the brain, fear has tremendous damage on your brain, according to her, if you take an ex- ray of the brain that is stressed out, it will have a thorny, jagged appearance as opposed to the healthy brain that is happy and well kept, the ex-ray now appears to be blossomy and flower like. She indicated that fear causes lockdowns where God cannot get to you she says today is your greatest day.

She also suggested, to get to victory you will need a road map, your faith comes by hearing the word of God, where there is hope and evidence. Being informed by the specialist (*whose name is* not *mentioned*) was televised. When she was addressing issues about stress; she says, that the stressed brain is visible in the ex- ray the toxic thoughts causes thorny appearances where that person is fear driven the positive brain looks flourished and blossomy and healthy, fear and abuse are the root of all stress, fear brings the thorns then internal poison begins to drip; according to her statistics she indicates that 95% of mental illness comes from stress related toxins.

My favorite scripture is: My favorite scripture is found in

Proverbs 3:5

"Lean not on your own understanding in all thy ways acknowledge me and I will direct your path." Plan bigger, escalate and grow if you find that you are frustrated that comes from poor planning we are to "Fear not" we must believe and trust.

The book of Ecclesiastes teaches on wisdom

What are your afflictions, your abuses? Believe that God can take care of them. You have to give your life over to him.

Let's say the sinner's prayer with me together.

"Heavenly God we come to you now with this heavy burden, we are asking for your forgiveness as we repent from our past sins, we are sorry and we want to be saved. We believe in your Word and believe in you. Please put our name in the Lamb's Book of Life. We will now live for you as we allow you to live in our hearts forever" Amen.

If you prayed that prayer and meant it, God says he hears our prayers and when two or more Christians agree he will be in their midst.

My prayers go out to you may God Bless you.

The Word declares that you are now saved! If you are serious and you meant it; that's all you need to say to get started. You are welcomed into the House of the Lord.

Give Glory to God!

Faith is the opposite of fear, one must relieve himself from the Demon called fear; which is a form of a stronghold which are the negative restraints from the demons. Those demonic silent

voices are the negative forces that will have to flee; they are real and the battle it brings is also real. When advancing to using your knowledge; as you are fighting back authority and taking authority over your life; use the full process to combat the enemy and to over come those obstacles that will be coming your way. You can win this battle and you will become victorious.

You can actually pray outwardly speaking directly to Satan telling him to go. Cast him out of your life your body, Spirit and your soul from your life and your families' and from all Christians. Always end your prayer, by saying "In *the name of Jesus*". Jesus says he has given us the power to case out demons. Take your power you deserve the power and the glory and honor. God is your miracle worker and he will work a miracle for you.

It is possible that you can condition yourself to rebuke Satan, who belongs under your feet, today he is defeated, the power of God is stronger, that he heals a destructive personality.

The negative brain has chemicals that are having wrong quantities that are strong and grow memories that are attached and destroy; those toxins, in excess will actually cause confusion while choking the immune system.

She says: Cancer is manifested from stress and causes a battlefield it must be replaced by the word of God so that you can build new memories.

Proverbs 14:30

Keep calm so that you will have good health we should love

on another as Christ loved the Church you are somebody in Christ Jesus.

1 Corinthians13:15

Live, obey, act on the Word of God just wait and see if all things will turn out for the good.

Proverbs 16:32

Peace = Freedom.

The Bible teaches us that when you have a relaxed mind and body you will live longer. Forgiving all is what we are taught to do, not forgiving; controls you. The Bible tells us that a merry heart does the body good like a medicine.

Let the Joy come in your life joy and peace and forgiveness are your fruits of life, we can walk on his word. He has come to save not to condemn us.

Psalms 122:6-9

He has granted you access to the Kingdom to his abundance, seek him and his goods shall be added to you

Key: Love pays no attention to wrong doings.

You are now being ushered into the first stages of becoming empowered and about to receive along with a sound Biblical Doctrine the tools that will be revealing how your should *Handle Your Relationship*.

We have taken care of putting the enemy out to allow you to experience the purifying process that will be needed as final

results as you go before Almighty God we have clearly defined your monogamy commitment.

Now that you have investigated the Pro's and Con's and you have anchored yourselves in the Word of God and accepted Christ as you leader, you are on the road to becoming victorious.

The next Chapter coming up we will turn to another issue: How to become successful when the negatives begin to bombard against you; addressing what it will take for you to become born again:

As we are approaching this issue the reading is out of the New King James Version International Bible: *Being born again.*

As you are transforming into your new found born again way of life; carrying with it a refreshing feeling knowing that you can and will have victory over your relationship crisis, you might be one of the *readers who are already turning things around for the better.*

The Bible teaches, that God surpasses all, he comes in a simplicity form, not being a celebrity but as a simple carpenter, his motive was and is to bring dignity, without dignity you become carnal and doubt yourselves. God comes to you and to your family to save you from shame, he catered to the poor and the have not's.

God's purpose is to fulfill the impossible and wants us to build beautiful relationships and families and to build a beautiful world to live.

There is only one God. Christians define one God as God came to earth by means of Ethical Monotheism.

God is morally obligated to us regarding his love for us so therefore, if you are afraid of the dark you can simply turn on the light. Satan works out of darkness you will never know who you are until to come to God, your D.N.A. Heavenly Father.

God's transforming his saints into lives of clean living he has provided us with the fountain of purity, where there is no sickness or disease, once you have been delivered your life will be like a bubbling clean water fall with turquoise water gushing out of it and enter into the air into the streams of our lives.

Pros and Cons chapter two

When casting out demons you have the authority; Jesus gave you the power and authority to cast out demons already downloaded inside you all you have to do as Christians' is to speak and denounce the demons in the name of Jesus. Always end you prayers by saying: *"In the Name of Jesus."*

The Bible in the Book of Genesis: Indicates that we have dominion over every living creature and over the enemy Satan.
You have been authorized to take that Godly Power and use it to help someone else who is suffering and under the power of the enemy in the name of Jesus. Make it clear to God that you are willing to give everything to him to lay it all on the line for God to honor him.

The Bible teaches that we must study to show ourselves approved, nothing comes easy in the life, if you are to represent

God as a willing worker, you must study the word of God to show your self approvable to the world. Educate yourself in the word of God, to represent him, you want to do your very best and always work hard with diligence.

The Word teaches us to put on the full armor of God, we are to witness and glorify God. Putting on the full armor of God is where we use what we have; our knowledge is our weapon against the enemy. God's full armor is his Word we are to use our word knowledge to get what we need accomplished.

There will be humiliation, it can be humiliating when you are the only person at work who is witnessing to God to see the stares. Jesus referenced that:

If we are ashamed of him he will be ashamed of us before God. It is obvious the workers are few. We are supposed to minister to one another, we are born as Ministers of God and we are called by God to go and tell the world that God loves them and there is Hope. We are all called to teach his Gospel.

We have a moral obligation to bring his Gospel to the sick, the hungry and the lost, and to feed the hungry. *"Go out into the entire world and preach his Gospel.* It is his request to his Christian followers.

We are to lay hands on the sick and preach to the lost to feed the hungry and the lost all around the world, there is plenty of ministering yet to be done.

You are now finding that you have been concerning yourself with your relationship and you're finding that there is not much

time left to focus on the immaterial things that seemed important at one time such as: that argument you had last night or that jealousy act where you created a scene; but rather, you are now finding that you are confronted with a much bigger Christian Vision before you.

With reference to a Christian man who happens to be a friend, and who is a Psychologist, who has enlightened my life with these helpful tips about relationships, his informative information indicates: Your approach to handling conflict could be your problem, in most cases where arguments flare up, it is never about the argument per say rather, it is about your fear trait that is out of control, as an example, when someone hates you, that is their problem; don't buy into it. If they have chosen not to become a hater let them have their hate party.

Another cause for crisis we also get ourselves into a crisis is when you try to help your partner when they did not ask for it. *If it's not broken don't fix it.* It can be detrimental that imposing God's word upon someone who is basically not interested can be very irritating and comes off as being offensive.

I have a friend who has struggled for years with a disease in her body. Although, I know a known biblical fact that the soul realm is where the sickness starts and that is where Satan enters.

After deciding to Minister the Word of God to her one day not knowing that it can be improper to minister to another person, unless you get their permission. Later, I was informed that she had a negative response with my efforts to minister to her.

Needless, to say, I learned a very good lesson from her rejection. We have to learn how to let other's be who they are; even if it is a family member; when families get together during the Holidays, where you have to be around family members you do not prefer, there are a few attitude adjustments that you can adopt to help you get through that day. This list helps you with difficult people, when you are finding yourself in their company.

a. You can kill them with kindness.

b. Pray over the day, ask God to intercede.

c. Tell them you love them to start the day.

d. Escape and go out of town.

e. Keep it light and casual.

By telling yourself it will soon be over is an excellent way to relieve and comfort you.

Adversities arrive when someone gets offended by the other partner, they are thinking you were rude, or inconsiderate in what you said to them, leading your partner to eventually go off on you.

The best way to handle that, is to first identify your offense, just know that you do not need to validate your partner; tell your partner you realize now that you unconsciously interrupted and that you admit to it.

That will solve that issue; work on yourself, rather than concern yourself with your partner's attitude, you cannot change

you partner but you can change yourself into becoming the best you can be.

There will be annoyances; take back seat driving as another example, or just nagging is something that drives men crazy when their partner is trying to direct the driver; being bossy in general is a trait that will need your immediate attention.

Find ways to improve yourself; ignoring is also a great tool.

Key: When you slow down and think about it the second time around things are not nearly as bad as you thought they were. Changing others doesn't work and never will, it could cause danger to erupt your safety is important there.

key: You should hang around people who think the way you do, people who like being around you, go where you are celebrated not tolerated.

Fool proof way to get approval from your partner.

*Go to your partner and tell them that you are there to accommodate them and help in being supportive to them in a Godly way. Make an offer to them that they cannot **refuse by assuring your partner that your intentions are to glorify God and to make certain that God is included in your relationship in a loving way. End by saying "I love you".***

Getting upset allows them have control over you, hang on to your emotions, keep it under God's submission God's gifts always goes out to help the humble, remind yourself to be humble in all things.

Judith Carol Cole

Fear again is the culprit, arguments stem from your personal fears. When you get offended wait until later when things calm down to talk about it.

Key:

Concern yourself with making improvements on yourself rather that concern yourself with changing others.

You are having a casual conversation then all of a sudden someone gets angry, the cause for the going, off is usually triggered about something else, obviously, fear is the culprit in arguments which produces the anger to erupt, or maybe some hidden or smothered suppression arises from the past. It could just take a few moments each day to slow it down and know that usually it is not as bad as it seems. It is a fear tactic bombarding you, by allowing fear to enter exasperates into making over dramatizing.

Key: *There is a hero inside of you waiting to come out. Everything you need is already inside of you.*

These tips are wonderful rules of thumb that you will need to apply to your list of thing that you should not do.

A. Never assume that things are greener on the other side normally it is never greener on the other side, although it may appear to be.

B. Never compare yourself or as a couple to another.

Words of wisdom:

74

God is not a respecter of persons what he does for one he will do for the other.

Whenever you are in public; always be respectful towards each other, never put your partner down in public, even if you have to fake it. If a problem occurs wait until you get home and after things cool off to calmly discuss it.

When you are alone and away for an extended period of time, longer than anticipated always, call and your partner to let them know, not to worry, you are running late. This is a common courtesy that applies to having good manners and being consistent.

You might want to add this to your investigation list: Intimacy and drives will vary from someone who perhaps prefers a very active lifestyle and let's say they are highly sensuous type; to a rather reserved quiet type that would rather be left alone type; this triggers another challenge where you will be comparing your drives to make sure you are compatible in significant areas, before you say I do. This is another area that you will need to investigate seeking compatibility traits.

Two of the biggest problem areas know to mankind that causes crisis for couples that lead to break up's are over *money problems* and *unfaithfulness issues.* In your investigating you will need to check out your partner's money spending habits to see if you are complimentary this is a very delicate area to be investigated.

Infidelity is wrong, there is no way to justify cheating on your partner, when he goes out and cheats may times he says

it was his partner's fault, she forced him to do it because of one reason or another. Wrong!

Cheating is the most undignified, disgusting sinful act that one can possible commit. Not only are you taking a chance on getting caught. You are also risking bringing a deadly disease to your partner.

Ask yourself if it worth it? Wanting the best of both worlds is not in the rules, you are better than that, Ironically, cheating people have many reasons and will justify why they are cheating.

Reasons:

For men it is their testimony why they cheat.

Because she turns a cold shoulder on him

She nags too much, she is disrespectful

She spends too much, shops too much

His mistress makes him feel good about himself to justify cheating will only complicate matters more, if you know you are self centered and selfish and you have no control over yourself you should stay single.

Marriage is all about having the capacity to give until it hurts. The negative traits in your partner are what you will be investigating; some of the traits as a suggestion that you want to investigate are:

A. Being short tempered

B. Having jealousy that is untapped that reappears when there is no justly cause

C. Being inconsiderate of you and you thoughts

D. The devastation of having doubts that there are acts of infidelity. In you're choosing the 'right person' or just enhancing your own marriage skills, will allow you to do your best.

Chapter Three How to succeed when the negatives are against you.

The method, used is fool proof so that when followed properly you will obtain the freedom to go forward as you step out in faith, to allow yourself to engage in the pleasures of a fulfilled loving life.

In this Chapter, you will be taking a look at ways you can become successful by eliminating the con's, the negative traits that are coming against you, and by intensifying the pro's which are the positive traits. Using this assessment process will aid you in identifying those negatives that have haunted you and prevent you from going forward; by destroying them, so that you have access that will allow you to begin to resolve those issues.

The process of elimination rules out those obstacles that have gotten in your way; fear not, they are about to get eliminated; the

objective is to find your victorious life in your own self first, then you are in a better position to find fulfillment in your relationship and marriage.

Before you can become empowered or victorious there will be some tearing down and closing some negative doors and opening some positive doors to help you; when there is re- arranging in your life; you should be praying, ask God to help you discover ways to let some things go that are hindering you.

The process of elimination is where we will begin:

Things you need to let go are:

a. Disappointment

b. Anger

c. Bitterness

d. Jealousy

e. Selfishness.

Disappointment can be one of the most harmful emotions one can contain, it shows severe neglect to God for all he has done for you. You are lacking and fail to receive his teachings that you are to never let the enemy still your joy.

Your anger is a result of unresolved issues, that are going on in your psychic, they have unbearably entered in by a subconscious access. Being angry at your mate because they didn't conduct matter, according to your ways of life, leaves you with either hurt feeling or a feeling that they disrespected you. Anger carries a

tremendous control factor with it; we know by now that trying to changing another person will not work. To examine another's viewpoint, personality and habits with a microscope shows not only are you too critical, but you are not focused on the big picture. Too much of your time and effort is being spent on the small picture, much prayer is in need in the direction of pulling you out of your self insufficiencies and doubt that could very well be part of your problem.

Bitterness can be a severe case of acting; out due to a broken heart, it is a form of self hatred, from your pain and hurt from someone you loved dearly; guess what? Get over it, everybody has taken a punch in that area, somebody has hurt all of us at one time or another, you are not out there alone your bitterness shows that you 'cared' about someone perhaps your partner. To care can be very harmful to you should *cast your cares onto the Lord.*

The Bible teaches that we are to cast our care onto him, why waste the time on cares on a human being who will fail you be aware that a person will let you down. There are no guarantees that you will have a perfect relationship; when you hold on to your cares you are actually being disobedient to the word of God. His word clearly directs us to cast our cares, which are nothing more than demons, Cast into the sea of forgotten you will feel 100% better and God can freely work things out for you.

So you are no doubt saying your partner did the unmentionables; causing you many nights of deprived sleep and emotional distress which has now led to depression.

The good news for you is be obedient to the Word of God you are expected to cast that care, this is a very difficult thing to do, it is only humanly natural that you try to fix your situation yourself, rather than cast your cares, meaning you have to stop, think, and listen.

The Holy Bible tells you that we are not to walk in offense when you are offended, you have allowed the enemy to come in and control you when that happens to you; you lose. You are not created to be a loser.

The three components that you will be approaching, such as, Christianity, common sense and psychological advice. Whether it is large or small it doesn't matter, what does matter is that you have the authority to cast it out. This is a tough place to find yourself; and many struggle with the issue of offenses in your life however, if you are viewing from the big picture and focused on God you can do it by handing their offense back to them with a *thanks but no thanks.*

What is jealousy? Suspicion and envy jealousy stems from a guilty conscience or insecurities in yourself, failing to identify with your self worth telling your self "The other guy has more than me."

Jealousy is one of Satan's bigger traps; it is his lie, and all lies come from Demonic forces from hell. **Key: The mind or the soul is where Satan gets his access to enter and convinces you that you are less and inferior to your partner.**

You are not less, you may have less money than someone who

happens to be more financially blessed, however, that does not mean you have less credibility with God. We are not defined by nor validated by how much money we have. In fact, the Bible teaches that the *Love of money is the root of all evil.* Never give permission to Satan to take away your love for God. If you are not wealthy or rich, it could be that you are not properly managing your money, if you wish to become wealthier there are further adjustments that will get you there financially.

You are given incredible gifts, within you, there are gifts that God has granted, therefore, the difficulties are recognizing them, you will need to identify your gift; find out what area in your life you would consider to be your strongest area where your talent might be located? Maybe you are a singer or athletically inclined a great chef, a teacher, a speaker, or a talented instrumental person whatever your gift. You are about to discover what you should do with your God given gift of talent you don't want to miss this!

You will be finding also in the words of God located in this book; it is intriguing to say the least, when you discover his truth and discover how God and his anointing works in your lives, when his anointing is being applied or poured down on you, as we continue to learn from him allowing his Spirit to spring forth to minister to you through these writings to you.

Glory to God!

For couples:

As you are investigating ways to monopolize your talents, we must start our endeavors with prayer. We are to pray daily. There

is a Spiritual war going on constantly, the enemy is far too great for you to miss a day without the Lord's. Prayer it also works better when you get on your knees. It is through your submitting and humbleness that God speaks to you. When you give God your hearts and your full attention, you can now repent before your Father.

Spiritual cleansing oneself before the Lord is an important step for finding your riches; purifying removes the toxins and decay that the world has placed in you; lays aside Spiritual weights and heaviness that are clinging to you.

God says in his word that we should come to him just the way we are. You must be in a receiving mode to receive your heritage when it arrives. Be watchful with a clear mind not to *miss your answered prayer.*

It is a requirement that you are a believer in this process of becoming a believer will be one of the most important steps you will encompass in your recover to claim what is yours from God.

Your Bible commands you to believe to receive; find ways to open the door to receiving and believing that God will restore back to you; every thing that the enemy has stolen?

Next, you will need to discern your faith, without faith you can do nothing in Christ Jesus by faith you can have the blessings from God. Put on your robe of righteousness as you are transformed into his likeness, while seeking for your prosperity

from God. It is far more important that you know you are saved and going to live with God in Heaven when he returns.

Being saved and being financially prosperous goes together it is through being obedient that you are financially stable you must be focused on God you have the word of God embedded within you and basically spend time studying the word of God then step out on your faith.

This is book will coincides with God's anointing and allow the empowerment that you will need to assist you as you go forward.

IF YOU CAN BELIEVE IT YOU CAN RECEIVE IT!

Position yourself for your miracle; and it is imperative that you get a plan. Planning is not a difficult task anyone can get a plan you don have to be a genius to get a plan.

I would urge you to direct your planning in the area where you are the strongest and most talented, prayer is the ultimate requirement it reveals you your greatest talent, if you do not recognize your gift; continue to pray about it, God assures you that your prayers will not return void, he hears your prayers.

When the time has arrived and you clearly know what talent is your greatest, the process can begin you should now be in the giving mode and finding life more fascinating.

Deut. 23 21-23 and Deut. 28:21

The *'giving' mode* is where you will find God the Kingdom

of God. In addition, it is where you will find the ability to share what you have with others who are less fortunate.

A valuable key *"It is better to give that receive."*

You now have a valuable key that will open the door to your financial prosperity , by sharing and using fervent prayer you will be successful in every area of you life, you are a King's kid you are Royalty and a member of the Monarchy of God, even though few have lived up to their fullest potential in God.

God is always there, and gives you credit that is due to you when you enter into the act of giving to others and sharing your gift, is where you should be at this point in life, giving to others that special gift that God has given to you; at which time you can specialize or capitalize with your gift.

It is important to note that out of your giving you give 10% of your earnings back to God, you will need to decide in what area you wish to give; to your local Church is a good deserving place to start, assuming they are properly teaching the Word of God.

You must find a place or a cause to tithe your 10% otherwise, you will block your blessings and fall into a disobedient mode. You are avoiding having the other 90% to go into the spoils or become contaminated.

It is recommended you tithe into the place where you are being fed the word of God, the place where you searched for God and found him and his glory where you were taught the Word of God. You are appointed by God to Tithe 10 % of your earnings

As you are faith walking in obedience, in your discoveries of the Word of God you are now discovering what it will take to become all that you can be to glorify his name.

Matthew 13:18-23

The Word allocates why you are asked to tithe in accordance to the word of God. Read the passage so that you can begin the tithing process if you have not tithed in the past.

You are now in the initiating stage of this mission it is time for you to take your plan and go forward remember God is with you.

Let us pray:

This is one of the most anointed prayers, I have prayed or ever heard in my prayers in my lifetime.

Heavenly Father, as I am connecting with the reader we are in agreement and lining up with your Word.

Father God we come before you together as a Christian Author and Christian Readers in agreement. In your words you have told us that when two or more Christians come together in prayer you would be in our midst.

We believe you are with us Father we have our needs and out of our insecurities we are asking you for the strength go forward with our endeavors to improve our lives. We ask that you take away those doubts and insecurities that get in our way and replace our fears with your fullness.

We give our lives over to you as we cast our problems into your hands; help us to take our gift to apply it where you can use it to glorify your name.

We are to believe that our efforts can now spring forward and we will become anointed by God at this time. We ask that you stay with us at all time and help us to make the right choices, as we venture into this holy place as we are now attempting to connect with our financial prosperity, believing and trusting that you are with us and you will honor our hard work and obedience; We are now applying with you that we be the best and do our best with our God given abilities.

Show us the correct way, Father we love and adore you it is our sincere desire to please you always.

In Jesus name we pray. Amen.

With the whimsical freshness of a new day your assignment is to begin with taking your plan to the market place; the place where your specialty will sell; you will need to take your plan with you mentally as well. How you sell yourself comes into play now therefore, you will need to fine tune your selling techniques now that you are taking that first step; by incorporating your gift and applying it in that direction so that you are now tapping into your Kingdom connection and with qualifying yourself. That is the formula for success.

The enemy is out there to discourage you from becoming financially successful, it is easier that one might think, once you have stepped out in faith you will find that this process is such a

simple thing to do and you thought there was some tremendous far away mysterious reason why you have no financial success when all the time your money was locked up.

Aid of Execution is now in process.

It is amazing how you can inter weave the Bible Scripture into your relationship problem and come out of it with the solution. It's like bingo you get your answer, you thought it was a difficult task, yet the answer was as close as the nose on your face.

Out of the1188 Chapters in the Bible, your answers can be found within those Chapters, your faith will not get you out of trouble but it will get you through it; you will have tribulation.

God has you covered regardless, to what the enemy has taught you are your own worst enemy, your fear has to be brought under subjection regardless to what you have gone through peace and joy is waiting. *"Open you the gates and be lifted up."*

Others will see where you are raised and transformed into being a *Blessing* and no longer living under the enemies curse. God word tells us that he will fight for us those who condemned us; therefore, you can forgive yourself and your enemy.

Prayer: *Thank you Father for your truth; thank you for your Son; the Son of Man; Counselor and Prince of Peace.*

You are welcomed in this place in our hearts welcome Holy Spirit we welcome you as you are healing our bodies and bringing the light allowing us to show love; help us to no longer be too hard

on ourselves. You have a great destiny ahead of you your healing is coming.

You are now in Treatment.

The best gift to give is to give the gift of the word of God he is still in charge, you have his authority take it, and we are here to be a blessing. *My Pastor for almost fifteen years is a true Blessing to me as well as to my family even though I have moved away temporarily from his Church located in Dallas, Texas U.S.A. there is a possibility of returning. He has been an eye opener to thousands who follow his Ministry*

To order this Book: Email to: msjudi9@yahoo.com Or Call: 469-765-5207. Or Mail your book ordering information along with your check or money order to Cole-Book P.O. Box 2602 Humble, Texas 77347.

The Book is $18.95 allow up to 3 weeks for delivery. Postage and handling is $3.50. *also sold online with major Bookstores.*

Give us your name, address and how many books you are ordering?

If you are interested in a partnership with this Ministry for your Church or coming events, let us know.

You can send your relationship question with your order.

God's Commandments: *Deuteronomy Ch.5 is significant in our daily walk for our success in the eyes of God. There are the* **Ten Commandments** *that we are to obey. You will have no other Gods before him. You shall not make before yourself a carved image,*

you shall not bow down to them or serve them. You shall not take the name of God in Vain. Observe the Sabbath day and keep it Holy. Honor thy Mother and Father. You shall not murder, commit adultery or Steal. You shall not bear false witnesses against your neighbor. You shall not covet your neighbor's wife.

How to succeed when the negatives are against you

In one of my Pastor's Sermons he says: "HURT PEOPLE, HURT PEOPLE." That is so true, it is just a natural product of life, if you are hurt from within, just being around others could cause your hurt to transfer on to them.

So you had a bad year maybe you lost your job or coming out of a bad illness or just depressed.

There is hope for you, God loves you and wants to bless your situation; your crisis doesn't get too big for God just know that regardless to bad your situation, God can fix it. He is bigger that your problem.

We are here to be a blessing to others; to the hurt to the needy and the lost.

God heals, know that your crisis can be over by the time you finish this Book by faith, as soon as you begin to believe in God that you can be healed, you are healed, don't question the word of God just believe it now and receive your Spiritual Counselor God.

God knows our intention, we don't mean to mess things up it just happens God has made promises in his word he says that

you shall walk and *live in prosperity and healing* that he has come for that reason.

You are pleading insanity from the past and asking for another chance you are no longer guilty God is a God of second chances go for it! You have asked for a second chance to get it right therefore it has been granted.

It has been granted to you.

You will not be denied, your faith has been properly delegated to God, seek him you shall find him if you knock the door shall be opened unto you.

Key:

Do unto others as you would have them do unto you.

His love is built on nothing less that the blood of Jesus Righteousness.

People tend to make mountains out of mole hills and out of there exaggeration they have God's plan built up to be the unapproachable and unobtainable. It is not that way; God is near to you he lives in your heart; therefore after saying the sinner's prayer when you asked him to come into your heart and live with you in covenant with him, he will do it and you are now saved. You are required to repent from you past sins and execute Gods' Judgment for your life and go forward in your new covenant with God.

God says, we are to repent from our sins and turn away from wrong doings; sinful living is only a reflection that Satan is still

ruling over your life the higher you go into God's word, the wiser you will become allowing you to recognize Satan quickly.

Being able to out smart the devil is worth the time and effort, he has been out smarting you and ruining things in your life all this time; you are no doubt realizing that he has to go; not only am I revealing him as the culprit, he is also the reason you are having the relational crisis; by using your rebuking methods, he is now going to have to run; when God and Satan are in a war God always wins over Satan Good outweighs bad every time.

Once you have taken authority and cast the demons out of your life, will be a better playing field how can you lose when there is no opponent? There really is no opponent once he is kicked out; the problem is he will reoccur. That is where the daily routine and hard work enters into play. Satan is manipulating and has the luring skills to convince you that wrong are right. God has given us his Spirit to discern the difference the good news is that for every trick that Satan throws at us God has a solution that will resolve it.

The power of Satan is great and not to be taken lightly you will have to have all the ammunition you can manage; still it will be a daily effort to keep Satan from destroying your life.

We now know what we are up against and that brings with it the need for intra dependency lifestyles, God has a calling on us requiring us to all come together in unity to fight off the enemy and declare your independence with your almighty Father there is an urgent need to fellowship and grow closer to each other.

I was watching one of the Christian Networks and learned that when the return of Christ comes, God has ultimately already spoken, and he reminds you that the people left behind will not have his mercy.

Can you imagine what it is going to be like without the mercy of God in your life?

It is trough his mercy that we are still alive.

It was alarming when the narration showed those beast, wild animals that will be unrestrained and roaming around and about devour whatever they want. God will be taken back up into the sky with his Christian believers and will no longer be there to protect you, at that time, you will be on your own.

The Book of Revelations is great reading that will explain the definition of *Hell*, some of you think you are now living in hell no! The hell you are now having will be a piece of cake compared to what the readings of Revelations are teaching about hell from the Bible teachings.

That, my friends, puts the fear of God into the average person, even more so; there is nothing worse than missing the mark, we might as well go all the way with this Journey to get it right! It is imperative that should get it right before the eyes of God. Glory to God!

Along with you 10% tithing and daily rebuking of you sins. We must move on up the Kings Highway.

For the men:

If you have chosen a partner and now having read this Book you should have no problem in your leadership capacity you know that you have the responsibility to lead her in the right way, love her, touch her; deny yourself of the wrong doings.

Putting God first in every thing you do you have a daily obligation to God first, if your partner is with you and investing her time with you, that will require you to direct your relationship in a manner that is complimentary to her allowing her to feel victorious. Just as that old expression that says," if mama is not happy nobody is happy." That is so true, the lady of the house sets the tempo inside the home she has to be made happy someone jokingly said that the food even taste better when mama is happy!

You should be aware that your problem was not as great as you thought it would be you have a list of ways you can make her smile, as you are advancing from doctrine; you have been equipped with your basic needs therefore you will need to execute them, we will be covering in the ladder chapters listings that will relate to additional empowerment issues.

Success

We are taught that Satan is a fallen angel, from the fall of Man when Adam and Eve made the decision for Eve to eat the forbidden fruit against their warning from God. He was then was casted out of the Garden of Eden, due to his disobedience and now assembles himself among the people on earth.

We all have to live with that monster called Satan. And from time to time we are all tempted to serve him.

The objective:

The primary objective is to be an over comer we have to find ways to excel above the acts of the devil.

Satan's reason for being here on earth is to steal kill and to destroy us all, as our Bible teaches us we fear, and believe that some people will not heed to his callings and we are fearful that we will be left behind we are to wait until the *Return of Christ*.

The Bible teaches that no one knows when Christ will return and it encompasses that we must be steadfast and obedient and wait upon his return, he will come like a thief in the night. I have seen a few situations in my many hundreds of visits made to various Churches, one of which I will share with you. There was a lady who was possessed; she called upon the Minister to rebuke Satan out of her body.

The Minister laid hands on her and spoke outwardly for Satan to come out a few minutes later the lady's facial expression changed and her voice changed as well. She now is under the illusion where her voice is of a heavier tone and her face was a gruesome site. This process was timely when finally the Demon was rebuked and had to leave. You can actually view these scenes where the rebuking sessions are taking place. They are occasionally televised. This lady was left *laid out on the floor* and unable to get up off the floor for hours. There are thousands of

cases recorded of Demon possessed people who go to the Church for the purpose of asking the Ministers for their help. It is well known that people are walking around today possessed with Demons.

Since God is a living Spirit, he uses our bodies to flow through us, when one is transforming to meet with God in the Spirit one must become transformed out of the flesh status; being transformed into the spiritual sense of being with God meeting God with expectancy. This all happens in the Spirit realm.

God has made promises to all of his followers and we naturally have our expectancies. God tells us in his Word that *he has come so that we may prosper and be in Good health.*

He has assured us that *by his stripes we are healed* the stripes he suffered while being beaten of that old rugged cross as he has taken our sins with him to the cross after his death and resurrection, that is why we have to cast our cares over to God. He says he will *cast our burdens into the sea of forgotten. As far as the east is from the west and the north is from the south.* God has the Power and Authority to resolve your issues.

Isn't that Good News?

Recently, I mentored a couple who are acquaintances. It appears that they are going through relationship drama let's call my friend Mary. I got a call from her; out of desperation she sounded as though she had lost her best friend and requested that I spend some time with her helping her decide if she should take her partner back; it appears that she has spent about five years

with her partner as they lived together going through the normal channels of drama as most couples.

During their courtship, I am finding that there has been emotional insult to injuries that she had received. Since I am representing her as her *Christian Mentor* I proceeded to take a look at what was happening; causing her to feel so down and out and this is what I discovered. Hold on to your seat belt.

She like thousands of women who have moved in with the male or visa versa hoping that they will marry some day soon; in this case, it was nearly five years of her living with him finding that there is no marriage and nothing has happened that indicated marriage is on the way.

When she confronted him with this marriage issue he would read off a list of complaints he has against her. He expected her to change these things before she was worthy of his hand in marriage. Needless to say, she is who she is and people do not change therefore, she carried out a continuation of being herself.

My impression of her is that she is pretty normal in her behavior. I have known her for many years and see nothing abnormal about her; he apparently is finding that marriage to her was not going to become available until she got her act together.

This entire scenario leaves him questionable:

"If her so called bad habits are so offensive, why have you continued to sleep with her and live with her?" It almost appears that he is wanting your cake and to eat it too, wanting the best of both worlds?

This particular phone call Mary informs me that she has finally caught her X- boyfriend with the other woman, she is now in a vulnerable state of mind. Mary is desperately needing someone to lean on. Recently, she decided to visit him unexpectedly, only to find that he was not alone after all the time invested, she is now pregnant in the ladder months with his child.

The two of them are separated and have been for months although, she is pregnant and has been angry and for months she has planned to just move to another state although, she still loves him. Mary is very angry because of all the drama he has brought to her, the nights he has spent going out with his friends, the anonymous phone calls, along with his obnoxious attitude towards Mary when she confronts him.

Now that Mary walks up unexpectedly, sure enough guess who was about to go out to for the evening? Mary's intuition told her there was unfaithfulness going on with him, she shows up at apartment and the other woman is there; they were about to go out; he was about to get into his car to spend time with the other woman and to his surprise up pops Mary.

The mistress is now in his car when Mary walks up to the car and says to the other woman *"who are you?"* The answer she got wasn't something out of a Cinderella fairly tale, there was some scuffling around that took place out of Mary's devastation she turns to me for help.

She is now informing me he is begging her for forgiveness and telling her it will never happen again. Now that his child

is about to be born he is obviously in a tough spot. Since the separation she has barely talked to him, now that she has seen the other woman, he has now added that that feature to his coming attraction.

He proposes marriage and begs Mary to come back to him and promises her that he will make things right *from this day forward* if she will give him another chance of course he says the other woman was just a friend and he doesn't want her. He calls the other woman while they both are there and tells her he is finished with her and it is over.

After the storm there is always a calming, now that some of the disaster has calmed down she is now trying to figure out a plan with a new baby soon coming she needs to come up with a plan and the time is now.

What should I do, she asks? The answer I gave her will be a twist from what you were expecting? She now gets the marriage proposal that she has graciously waited for.

Out of you pain and sorrow, you now have him in a vulnerable state of mind, that is to your advantage. He is now in a difficult place in his life and with this baby on the way, he is ready to do business, he finally admits he wants you to be his wife; as odd as it may seem I truly believe this relationship can be saved!

I suggested that she marry him! I am about to tell you why! I know this may sound a bit shocking. I am suggesting that they both get checked out by a Doctor. Just in case he was intimate

with the other lady or visa versa. After that let's take a look at what we have to work with.

I have seen many relationships break up. I think you should make every effort to forgive him. It will take many prayers to God to get over these offenses, but you can do it; women. as well as men are coping with these same issues daily and overcoming them and going on and living fantastic victorious lives; in cases where there is unfaithfulness met with great anxieties, however, getting that resolved and coming out victorious can be done with the help of the Lord.

My reply to her "If we expect God to forgive us, we must forgive others."

Once she has move on with her life and put the drama behind her knowing that one never forgets an ordeal such as this.

"*Marry him*" was my reply. Now that he is ready; you can allocate to him that physical exams., will be necessary. I have reason to believe they both have sowed a few of oats in the past. You have a family now and that is a good enough reason to try to work things out, he does not deserve to be treated like a hardened criminal.

If you will re-call she moved in with him mistake number 1 he was only accommodating her by giving her free rent. In his mind he was just trying to help her. She had a different way of seeing the relationship, thinking they were a couple on their way to matrimony because they were sleeping together.

This is the best example of what God is grossly against.

She wanted marriage before he was ready to commit to her or propose to her he never committed to her in those years which should have indicated to her he was not ready for marriage.

Conclusion:

She brought tremendous abuse on herself by making bad choices when she volunteered herself to live with him.

The problem here is that he never made a promise nor did he change his single lifestyle, until he was ready. He is now ready to make the change.

It is normally never greener on the other side although it may appear to be better moving on to someone else however, when you get there on the other side you will find that there will be another set of different problems waiting there also to be solved.

Summary

These are the do not's

The imposition would be on her. She imposed her marriage desires upon him when she moved into his house. He never promised her his devotion or his fidelity.

She suffered because of the way she handled the relationship. If she had waited until he was ready for marriage then moved in with him she would have saved herself all that abuse. She left the conversation to think things over, I am certain that they will marry however, their decision is yet to come. She loves him very much and he loves her, although they share in their differences, I could see no reason why they could not patch things up. The

secret is that she was also unfaithful to him although we never go to that in our group discussion. A stitch in time saves nine

The answer spoken to her:

" He has compounded his injuries on you in the form of neglect and infidelity with poor communications, he has failed to meet your expectations for marriage until now; and basically he is showing you signs of his inconsideration for you. Time and time again he has left you to doubt he has tested your ability to trust in him, he has shown you how belittling, he can be in his rude behavior. Yet from your choices you have been on a beat down with your emotions.

Never the less, the blame naturally, will come to you, getting pregnant is no reason to marry, now that he has proposed marriage and you have accepted, I hope that out of your trial and error, you will find a blessed marriage.

Failing to see the writings on the wall is the problem, he was not speaking the same language you were hearing. You were not on one accord. This relationship was grossly based on a misunderstanding.

He did not feel justified in your disappointment; In fact, he feels that his actions are in order and that he has done nothing wrong, he is a single man living a single life style. Although he is involved in fornicating, and of course that is in default to the Word of God to sleep around, he will need to honor his promise of fidelity to you.

He is now ready to commit, you get what you have waited

for, just know that you have chosen this man and therefore, you will need to work of keeping your marriage alive and growing with the anointing of God. Let us now take a look at what makes your female partner happy."

Things that make her happy:

The first and most impressive way to please her is to give her your time giving of yourself, will be the number one asset and she will appreciate you for your giving of your time. While you are giving your time, you will also need to know what to do with that time; when handling affairs properly; there is no doubt you will win her and lure her with fail proof methods that will get her attention.

Make her feel as though she is the most important asset in your life. In addition, use a list of ways that make women happy; it will be up to you to make her feel secured in knowing that she has chosen the right man, so that when she has taken the time to date you she is obviously interested. Women are basically emotional beings; her looks are a priority; since men judge women according to how they look; many times when women are younger, they can appreciate being the prettiest girl that is the one who got the guy, therefore, she has this urgency to quality herself in a physical way.

A female is and should be considered a precious commodity she was created to be appreciated pampered with tenderness and loved. Her purpose represents heart felt issues. She has a heart and her heart should never be toyed with or abused.

When he finds a wife you find a good thing:

Never should you disappoint or leave her to doubt or confusion. The Bible says: *When he finds a wife he finds a good thing. That is just good news!*

A precious flower she is, and will blossom into becoming Gods' greatest blessing, once she is convinced that you can handle her needs properly. The decision will be up to you she can be you your greatest asset and loving partner, if treated with respect or if not you could find that you are sleeping with your worst enemy, why not choose to be her greatest supporter and lover?

a. Women love to be touched

b. Hearing they are special and made to feel as they are special

c. They love to be nurtured and loved.

d. Women love to have your time

e. Women want to do social events with you

f. Love to go shopping or just to walk around in the mall

g. Go to a movie

h. Visit both of your favorite restaurants, regularly

I. Taking a walk in the park.

Women have natural maternal instinct

Things you need to know about your female partner or wife:

a. They are care givers

b. They are love bringers.

c. Sexual partners

d. Great companions

e. Best friends

In a loving relationship, she will prepare breakfast when getting out of bed and serve him royally, when she feels loved.

Serve him strawberries they carry the connotation of love.

Even though she might tell you she does not or cannot cook that is just an expression that she has other things that are taking a higher priority in her life. In recent years, women have gotten away from the old fashioned way of eating in; when it comes to cooking on a regular basis, it is not vogue to cook unless it is used as a specialty or in a culinary way which is an honorable thing to do.

If you can afford to go out to eat daily that would be wonderful if that is what you both agree to do.

a. She loves concerts

b. Dressy occasions going to Church

c. Adores camping out

d. Going to the beach or waterfront resort

You are now earning points with your female partner to win her over, she will actually greatly respect you when you show her you can handle things and that you are willing to participate by making the arrangements for the outings when you are getting

involved; be reminded that you are lightening the tasks so that she will not have to carry the responsibilities; the last thing you want is to allow her to carry the weight of the relationship.

Always open the car door for her and help her with her chair.

A favorite for most of the females that will win her over, big time is spending a weekend away, staying in a fabulous beach front hotel for the weekend, just the two of you this will allow the two of you to get better acquainted and help you to relax and enjoy the company of each other; now she gets to know more about her special man. Women are not hard nor are they difficult once you get to know them and once you have learned how to relate to them; you have conquered her by having a better understanding of what it takes to have her. Once that happens you can pretty much claim your victory at this point.

Women are adorable creatures from Heaven and there you will find a revealing of a new and glorious world once that door of opportunity is opened it will give to you, what God intends for you to have with much beauty and undeniable love.

There is nothing better in life that to be in love falling in love is a glorified Heavenly God sent way of living your life, it takes two so admit it you need her, go after her, women love to be chased.

They love to go out and sit in the corner where the lights are dim and make sweet romance until the wee hours.

Once you catch her, do what you now know to keep her

happy by doing those things that that will bring her a feeling of being fulfilled.

What makes the guys happy?

Some of the experts will tell you that it appears that the two most important issues that men prefer is they want a lady who is beautiful inside, in addition, loyalty and respect are highly rated, she will need to be intelligent along with having the ability to carry an intelligent conversation. The will want their female partner to be in good physical condition and not to be lazy; rather to be up beat and interesting, finding ways to keep the relationship exciting and growing.

With a new day upon us let be reminded that God is in charge we tend to blame him for our mishaps when all the time it was our disobedience that caused the problem. His Grace is sufficient.

We have been focusing on causes for the breakup and to the issues behind those break ups. Men are egotistical and sensitive by nature very much designed differently from women naturally they have different needs. If you are going to share in a relationship with a male partner in your life it would be to your advantage to invest time into finding out what it will take to keep him. These are some of the favorites:

a. He adores intimacy

B. Engraved jewelry

c. Computer gadgets

d. Silk pj's

e. A good book would make her a wonderful gift.

It is the thought that matters to him.

Men generally, will expect intimacy; on various levels, intimacy can be rated as a number one priority for the male although, he is not to be misunderstood, intimacy is not at all what he is seeking. Just know that he is expecting her to be romantically inclined. ***Comparing your sexual drives would be considered to be a major concern that requires investigating.***

If he finds that his female partner *that happens to be financially wealthy* that is not an issue for him he knows that he has to bring his own merits to the table. What he mainly wants from you is "you" he wants you to give of yourself.

Being a Christian would definitely grant you those extra points, along with that comes your effort and diligence to keep her happy. When God is added how one can lose. It would be virtually impossible to lose when you have God on your side.

There are many experts out there the P.H.D and the M.D and there are Relationship Authors and Christian Relationship Authors and Ministers to help with relationship issues, with all the great advisors available to you there is no way you should go without the knowledge and know how to get the job done.

As we are approaching these issues from a Christian insight tackling the issues, by using the Bible theory that is a sure way that

you can depend on, nothing else is dependable that is available to you except the Word of God.

Your physicians have their scientific approaches by using counseling and medications and medical approaches they have their proven track records, however, with the rising divorce rates it is obvious that the people need a change and a new and additional concepts.

In our law office, by the time the case hits our desk it is past the stages of resolution, we are mainly seeing the end results of a relationship that possible could have been saved but no one took the measures to save it.

In today's society, religion is more prevalent that ever before never in the past have we viewed so much on public networking so that if you cannot get out and go to Church you can get Church to come to you. The main issue is that you get it right. The New King James is a favorite for me. If you have followed the old and new versions of the Bible, you have yet to find something in there that was The New King James is a favorite for me. If you have followed the old and new versions of the Bible you have yet to find something in there that was detrimental. Therefore, by following their rules and applying them you will encounter your guaranteed you results.

We can now take a look at what pleases your male partner. There are a few simple things in life that will make him happy.

By using the Bible as our means of discovery we can still carry out the mission.

Men are our seed bearers, they are put here on earth to please the female they are your rocks, your providers, protectors and lovers *it doesn't get any better than that*. Men are those you can go to that can give you a shoulder to cry on, they are generally no non sense kind of guys, which encompasses not tolerating too much foolishness. Men are equipped to be disciplinarians if necessary. I am opposed to spanking; unless the partnering included the proper teachings for your child first. If you have not taught you child to do better naturally, you should not spank them for not knowing any better. The men will not spare the rod if needed with their physical strength that God has provided you have your protectors they are the watch men on the wall.

Men are in addition, excellent in the area of offering support and comfort to the female partner they offer great help in the area of financial empowerment adding additional assets to the relationship so that it has the luxuries that make your life comfortable. Men are our gifts in life. I cannot imagine life without men; they are care givers, seed bearers, weight lifting, Blessings from God!

Chapter Four Marriage Vows

Getting married is the honorable thing to do and should be sanctioned by God, as your marriage is a Blessing from God. Once you have said "I do" you should have your entire scope of Pro's and Con's well under control.

At this point, you are now being addressed as Mr. and Mrs. for better or for worse, marriage can be a great challenge there will be the good times and there will be the not so good.

A large portion of your results will be determined by your two personality types if you have compatible personalities, you will have a running chance of becoming an over comer. A good rule of thumb will be to judge yourself by how well your dating period turned out, if you struggled with your dating you can expect the same with your marriage.

If your dating turned out satisfactorily for the both of you

that is a good indication you can no doubt bank on it that your marriage will be a success being victorious is not a relative word and carries a blanketed reputation with it, everybody can use it.

We will be taking a look at what the Bible tells us about marriages the Book of Corinthians is used greatly for issues that relate to Relationships and marriages. The book of Romans is also good for teaching the rules of life.

Let take a stroll there to see what the Lord has for you there.

Marriage:

1Corinthians Chapters 4- 6-7 verses will vary

A few Scriptures out of the Bible says to the married couples:

Let a man so consider us as servants of Christ and stewards of the mysteries of God.

Now therefore it is already an utter failure for you to go to the law against one another why do you not rather accept? Why do you rather yourself to be cheated?

Did you not know that the unrighteous will not inherit the Kingdom of God? *Do not be deceived neither fornicators nor idolaters, nor adulterers, nor homosexuals, nor sodomites, nor thieves, nor covetous, nor drunkenness, nor revilers, or extortions will inherit the Kingdom of God.*

Flee sexual immorality but he who commits sexual immorality sins against his own body.

Your body is the temple of the Holy Spirit who lives in you

whom you have from God never the less, because of biblical immortality, let each man have his own wife and let each woman have her own husband.

The wife does not have authority over her own body do not deprive one another these are some of the instructions and warnings that you must know about.

Getting to know your male partner will be a revolving door that never stops learning about them, now that you better understand them, you should follow these instructions there are many ways to keep things interesting, now that you are married, or even if you have been married for years the marriage has to be kept interesting.

Those little quirks that got you together in the first place has to continue, hang on to that favorite stigma that turns you on, intensify it and use it as a tool when you get into a tough place. There should be no signs of personality malfunctions going on in your marriage, things such as, slamming doors cursing or name calling those are acts of immaturity, or maybe that is an indication that you have made a bad choice.

Keeping things lighter can allow easier access as to how you can get a better understanding of what you will be up against by living it out and by reading and learning how to solve your negative issues.

When the male has this attitude that he can come and go as he pleases, do as he pleases and has the attitude that he does not have to listen you his partner, he tells her not to interfere with his

thoughts or his whereabouts, is the thoughts of many untrained men think that a man is hen pecked, when he is accommodating and considers her first. The disobedient male will soon find that is where his head aches will begin the school of hard knocks and heart break hotel.

When she has a problem with him not helping out around the house, she is now complaining about having to do all the laundry, cleaning the grocery shopping and the cooking. While he sits there and watches the game, or he never helps out around the house. Those are most common complaints, not to be taken lightly, these are real issues and they might appear to be small however it is those little fox's that ruin the crops.

When you go back and look at why he married her it will probably be because she is beautiful and kind at that time, and he is attracted to those things? Although looks can be deceiving there is personality hiding behind her pretty face that often gets overlooked until later in the game, if you are feeling that there is hope you will have a fighting chance to save your relationship.

Often times, one of the partners wishes to take on another's mate, that is a well known choice. He made a mistake when the marriage was being played out, it turns out that it wasn't exactly the way he planned for, therefore, he takes a look at someone else to pursue; this is another popular complaint, one that you should avoid, catch it in the early stages to cancel it out before it is too late.

Another well known complaint is that she spends money like

it grows on trees, a very popular demand in the form of a major complaint.

Women should know that there are many complaints coming from men, who joke about how women spend money they laugh at it however, they are taking it very seriously, to assure you of getting closer to a quality marriage you should use caution with your spending, it would be wise to check with him first or allow your spending to become minimal

Try using a budget that would be a great way to control you're spending, marriage is a God ordained matter and created to be very happy and fulfilling.

Genesis 2: 20-25

This Scripture shows you why choosing was difficult and still might be. The woman was given to the man to be his helper not to be battered. In many cases, where the correct partner is not properly investigated and the chosen partner finds incompatible characteristics and indifferences; theses thoughts and outlook on life lead to fighting.

Be watchful for these signs"

When a couple marries based on only one activity that you both share, lets say you enjoy walks together, all other activities you both should share together rather than going your separate ways, constant arguments and unable to reason or agree on simple things such as taking a swim together will lead to trouble.

When going into the marriage you should check out the things

you will disagree with and take a look at several activities that are available that will make your lives more alive being together. The types of activities that bring you together would include simple things; walking, playing ball, or exercising which proves to be relaxing to the mind, when inappropriate investigating takes place, the results could lead to war causing the battered wife or husband, and even the children can be affected.

Note:

One second of unhappiness is the cause for an hour of mental torment, and far beyond, depending on the depth of the wound. Unhappiness is a costly liability.

Love and consideration would never cause a wound or hurt. The time allocated in getting it done the right way will prove itself to be well worth the time. The time spent will give you the advantage of contentment and helps you to find enjoyment sooner.

When you think about the reasons; it comes from a negative force such as the inflated egos, demands and selfish attitudes. When things becomes too demanding "I want this done this way and I want it now" that type of attitude the *How To Books and Self help Books* are there to help you to discover your true emotional needs in getting to understand your partner such as: compatibility, education, emotions and loyalty.

Pause to consider what a waste of time in view of human life and age, it is to enter marriage, and then spend it in fighting instead of happiness.

There is another example of the guy who couldn't give up the night clubs, this story represents many others. He nearly drove his wife crazy she tried every method possible even throwing the book at him to break him from running around and nothing worked. She suffered from High Blood Pressure and he was unhappy and unhealthy.

Apparently, he found justification in running around on his wife. I know his complaint was that she was a cold natured woman. Amazingly, when that happens a good question to him would be, *did you know this before you married her*? They stayed together until they died from old age having robbed them of the quality of a good marriage.

Generations ago, the marriage principals were treated differently than from today. When we were kids I remember my grand mother telling us if we made our bed we had to sleep in it. I had trouble understanding that one. However, now I know she was using that parable to keep us in line she was always right when she was helping to raise the kids.

Now is the time to set your goals and get a plan organized nothing different will come to you until you do something different, if you want your life to change you have to do something to make that happen.

Let us look at a piece of art work that may be a possible goal.

It is with love and a successful marriage combined that gives everyone around it, such a wonderful sight to see. Beginning with their dating and ending in a beautifully love affair put yourself

and your partner into the large work space. As you are dating, imagine that wonderful art piece that you designed is on its way to completion.

There is absolutely no rationalizing in continuing to live the life of a single person refusing to change singles habits and continuing to live in ways of a single life style. There will be some negative doors that you will have to close. Once you are committed you will have to think about your partner first and incorporate your mate into your plans for your daily living and while preparing for marriage. Once marriage takes place you will be prepared as a unit; never to be a single minded individual again.

What is one's reasoning behind still searching for what you already have found? If you continue to patronize or hang out in places you went to as a single; there you will find singles that are there and searching for what you have already found. Many of the singles' hide out in places that encompass where you will find singles that have a lifetime of scars and heartaches.

Next, you are striving to have a loving family where the compatible husband and the understanding wife love each other this is your goal that you have set out to find.

You must first get some rules, there are rules and standards that are connected to goals. Let us take a look at this as a goal.

Follow the rules that are set you will be compelled to follow these rules that will be a good place to start.

Ch.4

Add this to goal seeking we must put some restraints on. One cannot demand from others until you are in control of yourself, one cannot demand for bad habits to stop, if you have bad habits yourself, nor can one expect loyalty, if you are not being loyal. You have to be free of bad behavior you can become a new person with a new set of morals this will be your second goal to start over fresh.

So many articulate pieces of your life long situation are completed in a clumsy way, making them of no good use and of little value; make your path the way to a beautiful product.

Make your desires to share with your partner, there are turn offs, that will arise such as: having the feeling of being disturbed, worried, or in trouble. Consequently, affecting your partner in some way, this is your unseen expression of your internal feelings; how you are feeling about yourself not to be mistaken with something being wrong with your partner.

There is an art to recognizing that the internal is what is causing the outer reactions. Every marriage has to have it's discipline tactic, where there are no rules, chaos will occur.

Marriage

a. Make rules and apply them.

b. There will need to be some things taken away there will be some things added.

c. You both must take the time to explain in detail what the other is expecting from you.

D. Be thankful of who you have chosen to be your partner.

e. You must be equally yoked .

f. Enjoy the same activities together.

g. Slow down and listen with kindness.

h. Stay opened minded to new ideas and keep the marriage growing and interesting.

When these rules are not applied a disliking for each other could occur; where there is no love it will be impossible to stay together. When you dislike someone the feeling is intense and every part of you including your facial expression, body language, the tone of your voice and actions express the feeling.

The examples are true stories and coming from real episodes.

You should create a list of your thoughts, concerning your decisions and feelings resulting from those examples.

Your outlook will be better concerning a partner choice, and your picture of your marriage will become the most empowered, when you compare it to others who do not understand and did not take the time to get it done correctly..

Being kind to others is like having the gift from God and knowing that it is a gift to be kind, taking the gentle approach and incorporating kindness with gentleness in your marriage you find your reward will be nestled on the inside.

Ecc.3:1 everything has a time:

To everything there is a season a time for every purpose under heaven.

A time to be born and a time to die

A time to plant and a time to pluck what are planted

A time to kill and a time to heal

A time to break down and a time to build up

A time to weep and a time to laugh

A time to mourn and a time to dance

A time to cast away stones and a time to gather stones

A time to embrace and a time to refrain from embracing

A time to gain and a time to lost

A time to keep and a time to throw away

A time to tear and a time to sew

A time to keep silence and a time to speak

A time to love and a time to hate

A time of war and a time of peace.

In accordance to your Bible Scriptures:

We all love it when we are in the company of kindness, it is like a warm blanket on a cold winter's night, cuddled in front of a burning fireplace; how you describe kindness is to act it out, will depends on how are you using it? You can see that there are many qualities that a partner should have.

Remember, too much of a good thing is considered to be gluttony and not recommended although the more your partner has to contribute, that lines up with what you have is all the better although, greed is bad you will need to know the differences. Let us face each fact, namely the other partner's experiences such as; embarrassment at not being able to give.

If you can see the kindness traits; giving and understanding they are of equal exchange; speaking of equal exchange it should be with both partners; both must be given to operational feeling of this kindness drive together. We have all probably met someone in our lifetime that never smiles.

The Ebenezer Scrooge type: There are some of those types that we are meeting from time to time they resemble a grouch showing facial lines that described frowning, it happens that the facial expression distracted from kindness they are the ones that everybody fears. In reality they turn out to be very sad and lonely.

Marriage is a major commitment; think about it; you are giving yourself to another person there is nothing more important that giving of oneself. This is a lifelong commitment with hopes of reaping the rewards of having a partner and love that will last a lifetime. This is monumental and shows sincerity. Can you really make a statement that you know your partner? Many times one might suggest that they have a problem getting to know their own self.

Now you are a family, a unit you will be expected to work together as a unit by resolving the problems that come against you. Where one falls short the other must be there to

compensate. Together where one is weak the other should be strong encompassing a full circle.

Investing in your marriage and sow seed into it; being perplexed in this area, there will is little harvest from little sowing.

You will be thinking long term, now that you are married and thinking what is best for the two of you now. When you marry you exchange vows they are simple; to articulate you are pledging to stay together through sickness until death. Many never live out their pledges however, most have the intentions to do it the honorable way have. Making a conscious decision to marry coming from of an abundance of love for each other; no one else would take such a leap of faith, unless it is all about love. It will take love to keep you together so hold on to it.

What does one have to compare marriage to? It comes down to the fact that life is going to be what you decide it will be. You can have a beautiful loving marriage, if you decide it will be that way or you can stay single and still be a blessing and enjoy your single hood tremendously. It is essentially, about what you invested into the success of your relationship. In your daily efforts to improve your awareness, as you are finding ways to keep the marriage alive; you will master your marriage.

Being nice and using kindness is one of the most important human behavioral trait or patterns one can develop. An unrestrained smile along with a good understanding, once you mix that with a dose of loving kindness, this is the recipe for your success.

Isn't that good news?

When you were dating, or investigating the other person there should be a genuine interest; whoever you may be or become is what your life will be as a team once you have chosen to be together for a lifetime. When that time comes where things get a little tested and you begin to have regrets remember that nothing last forever.

Your words used against your partner may be a little harsh at some time or another you should stop and think about this a little more; what is it that we are trying to find out? If you find that these harsh words are used frequently then stop and ask just how compatible this partner really is? there appears some kindness traits that are missing, it is time to investigate this very important issue taking a quick check can show if the missing trait is missing from you or your partner.

Different views about the same topic can be is a popular complaint.

When a disagreement occurs you are arguing about a topic and no one is listening; by using the kindness logic after a while you will mean what you are saying and eventually it will become a way of life; it has its way of becoming transforming. Having the ability to laugh at yourself is a quality that comes from within especially when you have made a mistake.

Basically, when life has been taken too seriously, ironically the opposite happens; when we do not take life serious enough can be detrimental. There will be a need to find a happy medium.

Being the agitator is irritating to your partner and you must never allow that; rather reach for that little bit of humor that is

inside as your weapon of resolutions; see the humor that we all have that is locked up in a vault that is stored away and has *been on lock down far too long. The Bible tells us that "A merry heart does the body good."*

Brighten things up in your marriage by keeping it light and pleasant you will not be able to fix everything that goes wrong like so many of you have tried to do; but this should show everyone you are around that you are concerned enough to listen, do not carry the burden solely, of trying to make everyone feel good; rather just give a little kindness to them.

When speaking about the *LOVE* emotion there are rules.

The love emotion is the most difficult yet powerful one because it carries such magnitude and can be over whelming both men and women will have to a struggle with the love emotion; unless it is dealt with properly, naturally you will be finding it to be a sweet and adoring feeling of fulfillment.

There is a distinct difference between love and intimacy they are not the same, there are those, however, who choose to make them the same which is in opposition to the *Biblical* rules.

There are also those people who show their love to everyone, when you see them coming you know a big kiss and hug in on the way. One must have love in your life in order to live you are establishing a full life; what good is having love if there is nobody there to share it with?

In this Chapter, we will be taking a look at the importance of discussions. Coming up! We will cover materials that will

include: What the Bible says we are expected to do to get into the Kingdom of God. You don't want to miss this Chapter.

When the choice is to fight rather than discuss. The use of fighting versus discussion will determine the degree of happiness and contentment you will find in the close relationship of marriage.

The term fight conveys a very negative thought in fact; fighters will fight even when they are in the wrong. For instance take the man who was considered to be the town drunk. He would fight to go out with his friends and drink, talk loudly and obnoxious, he claims to know better than any body else about all the topics and he is just waiting for a fight. This type of fighting has no thinking process just a mass of confusion.

Take a Boxer, for example, that is another form of fight he gets his point across by physically fighting and throwing his body weight around and he punches his way through out the fight.

A family fight can be the worst one of all you may even hear the words that "you are showing preferred treatment to someone else" or be accused of being against your partner in some way; with this going on occasionally, there will be a possibility that follows some form of violence.

Money issues are highly over rated issues that causes fights. The fighter always wants preferential treatment. There is little chance of clearing the air when the fight is about money, enough of these fights and the love will leave.

Being in the legal business we are seeing plenty of fighting in our family Law Firm, I feel that I am blessed to be chosen to

work in the legal field. To be a business partner is a tremendous blessing from God.

We are hearing that phrase frequently. "You fight constantly" You would think such an issue could easily be stopped; to just stop the fighting, unfortunately, it is not that simple in many cases the fighting will not stop and cannot stop until the Law steps in and stops it for them which is unfortunate.

Fighting within ones family at those gatherings no one is listening the discussions are around those family members that you do not wish to be around. Over the holidays, rather than become depressing times, that is when families are together unfortunately there are unresolved issues. Fighting is a seed also, when sown into your marriage will take roots and grow.

There are cases where the fighting had gotten so bad that the two people were consumed with their hatred for each other and actually lost site on their surroundings, as the world was passing them by while they were fighting. One must proceed with caution in this very difficult and dangerous area it is an act of the enemy to steal you from your relationship without you knowing it.

You will ignore some things, finding that you have to pick your battles, living with a person who nags about everything is the creation of a bad situation to have to live with.

Solution can come out of fighting

It is now time to set some rules for a good fight some are repeated and some are new but the most common is that a fight clears the air, another common statement is that there is a

wonderful feeling of reward when you are making up. Fighting can be the cause for mental abuse which leads to divorce.

Can you remember when all the kind words and actions that you exchanged? Those hurtful words can not be erased and the damage is done and one can be hurt for a lifetime. Yelling and using curse words are deep and penetrating weapons, the same words of love that was spoken earlier coming from the same couple is used; you will find that there is a love hate thing going on when emotions are flaring. Words that are derived from self hated leaves deep scars for the other; no one has won you both lose in your fight.

The use of discussion is better, you both know from past experiences that discussion will result in contentment and harmony in finding that you can hold hands, kiss, laugh and play around with each other while; using this form of communication will bring excellent results.

To get started, using discussion is a simple process; first you may have the same subject that caused the above fights this is where it all ends.

You will be using the power of your rational mind to choose the most wonderful person for your life partner. Discussions will allow more contentment that is on your way, through life's journey why fight it? Just join in the thinking power.

Think about this, when you are the bigger guy meaning you are willing to take the initiative to say *"I'm sorry"* to heal the relationship problem, you will be more desirous, when you get home you will find harmony, sweet love and contentment. It just

makes good sense to turn things around from a negative where you are being denied your love.

The Bible speaks to us about our faithfulness to him.

The Bible is your guide and presents how you should handle relationships, that in it self will render the necessary aid and advice that you will need, we are to use prayer everyday.

God is our source:

God is obtainable he is here with you. There are those who are called to the Ministry; those are the people who confess to hearing from God; they are confessing that God speaks to them in a small Spiritual voice.

When in doubt always refer to the word of God; any deviation is not acceptable, nor tolerated from either partner.

A very significant key:

Clearly understand, that you are not living to please one another but rather, to please God, once that is accomplished you will have pleased each other. When you are concerning yourself with how you are living your life for him his loyalty and truth are inseparable characteristics.

When you look at your lives through means of pleasing your Heavenly Father, now suddenly you have your purpose for life. God created us in his own image. God happens to be our Spiritual Father perhaps to fill in for the Father, we never had in life; so to please him and live for him will coincide with living a great and loving marriage, the two just go together.

Take a look at how you must look in God's eyes when you are slamming doors name calling and fighting, not a pretty picture. Just think about the number of times you have broken the heart of your Father with your bad behavior.

Why would any one want to disappoint God with your bad BEHAVIOR?

Now we have a truth before us that we must live by; the truth that we are to live by the Golden Rule. *Treat others the way you wish to be treated.*

The Divorce Court records indicates the many causes of divorces; be reminded that break up was once a beautiful marriage, without loyalty your hurt can be fatal to your emotions the trait of loyalty is a delicate mixture of honesty and faith and a firm conviction of *Righteousness* and is an intricate part of your inner characteristics. Money and infidelity are the two leading causes for divorces.

A lie does not have to be told in answering a direct question silence is sometimes the same as a lie.

When you tell your partner *"I have other plans." I will call* you *later* those are lies when telling your partner knowing there are no other plans: As an example.

When one coveys the truth to his partner, regardless, to what the condition that may arise; once you are committed for marriage; loyalty with all it's meaning should be applied an added to the marriage pledge. Your attitude about your rules that have been set, determine whether you will fall into the trap of despair

or if you will find love and contentment. The choice is up to you; so that now *Prayer* must be included; it is essential for success this may be done first try it and see for yourself however, you do have a free will to choose; use it wisely.

You are now empowered and embarking on becoming compatible; there should be absolutely none, or very few, surprises after marriage after the wedding, having taken the necessary step of investigating you will save yourself a lot of time in discontentment.

Now that you have read all the facts, listed and looked at the many examples relating to human behavior, I hope that you will not say that you are sorry this happened to you and the unhappy fate does not happen to you.

Try to eliminate the sorrow and replace it with knowledge for you will blame fate, if you listen to only irrational judgment. *(Fate is the result of rash judgment.)*

Be ye not deceived, God is not mocked for whatsoever a man sowed, that shall he also reap.

Gal. 6:7-10

For he that sowed to his flesh shall of the flesh reap corruption but he that sowed to the spirit shall of the spirit reap life everlasting.

And let us not be weary in well doing, for in due season we shall reap, if we faint not as we have therefore opportunity let us do good unto all men, especially unto them who are of the household of faith.

That informative scripture carries a great deal of impact and should lift your awareness, as well as your partner's. We are to be encouraged and to encourage your partner, if you get weary in your well doing, the law of sowing and reaping works continuously, whether you can see it or not, if you have a problem believing your reaping will suffer; you now see this Revelation as it is unraveled? Can you in all honestly say now that you will no longer be guilty of robbery as it pertains to God?

Do not be of the impression that you can hide or make a fool out of God, he is God and he can see everything you are doing what is done in the dark will come to the light.

Our Bible teaches us in Job 2:

Satan roams around like a roaring lion in out lives. Darkness will be exposed with the light, demons dwell in dark a places that is where they live; the assumption that in this darkness you will find a hiding place and where no one will find you. The Bible teaches that the dark places will soon come to the light. When one is operating in the light everyone can see what he is doing. Satan cannot afford to be seen; if one has clarity in conjunctions with the word Satan's work would be worthless because then no one will follow him.

Satan has his rewards that he gives to those who follow him. The more experience you have recognizing him, the easier it will be for you to rebuke him off of your situation, as well as your family and friend's situation.

Chapter Five Knowing you have arrived in the Kingdom of God.

Now that you have your *turn around*; you might say that you have arrived. There is so much involvement and so much to absorb about the two people who have chosen to be together this will be continual learning process as you grow together.

The objective here is to discover how to find ways to love more and live longer.

By now you probably have figured out a way of becoming an over comer, knowing that you are your own enemy and your own biggest critics, there is a law that is universal and it applies to all. This law is from God's system, and *God is not mocked* you are not to bend the word to fit your disobedience. The word of God is concrete, what you put into your relationship is what you will reap from it no more no less.

There is a man that scatters yet increases.

The system keeps a man humbled because it makes him recognize his absence. *God is our Source.*

In the Spiritual walk Satan does not exist, we are living in the realm of becoming transformed into his likeness. As Christians your presence when we walk into a room the atmosphere should change.

We are expected to be living in Heaven here on earth to where going outside into the world will be like a slap in the face you are being exposed to reality now and having to deal with reality is like having two worlds to identify

There are three areas of concern as examples of goal setting they are:

a. Your methods

b. Your morals

c. Your means

Your *morals* will identify what you are willing to sacrifice morals are in our genes as well as something you are taught. Morals, properly executed are directed by God and come from God it is an example of discerning self worthiness, your morals will help you to create the process that will bring you to where you need to be.

The issues of right and wrong properly conveyed and properly deleted will be how you will determine the quality of your relationship. The definition of morals carries a connotation of

having a thin line as so with love and hate many times the truth has been altered to accommodate the wrong path. That thin line is easily stepped on and stepped over many times, that will occur unless you are prepared and equipped with the Word of God.

God says he will fight for us.

Stretching the Word or to alter the Word is the same as being unfaithful to yourself the Word of God speaks for itself and is presented to you in a way that you can understand it.

Your *method* that you choose will be expressly and uniquely designed by you, no one else has your method. Methods are the manner or style in which you choose to get to where you need to be by discovering who you are and what you are striving for, it is a combination of where you are going and what you need to have to get there.

There are no two methods that allocate the same results your method of planning, if properly directed will determine whether you will succeed or fail. And it will tell how far you will go with your vision.

Your method is a directing force that identifies your make up; your method tells others who you are and describes your personality type in addition, your method is your style and is uniquely a gift from God although all methods are not good ones.

A method has to be cultivated and rehearsed by preparing oneself it is through your diligence and efforts that you develop a positive method that will take you to that higher dimension.

Key:

There is a process in getting to that elevation anything worth having will cost you something to value God's Word makes room for him never allow yourself to be too busy for him.

Your means: This encompasses taking what little you have and giving it to God *he says in his word that where much is given, much is required.* We must look to him for or means and draw from his well. Your means are to have purpose in life, you do have a purpose many have not figured out what that purpose is but you were put here to do a job and fulfill God purpose for you in life. God is and will be asking for you to show him your fruits. He says in his Word he will be asking *"where are my fruit?"*

Your intentions or means when assessed by God will accomplish your purpose and define your process. So now we see that we have a process which is the pathway that you take that will lead you to the Kingdom.

If you should accidently make a mistake and you did not mean to do it that would be considered an accident because you did not intend to do it. You have a good intention that is what God looks at your heart and your intentions.

The Bible teaches that *when two or more believers pray* together *that he would be in their midst.* Believe that God's assurance is to take charge of everything and that is what we all must pray for, that he leads and guides your lives in his perfect way.

As we go further into the teachings of the Lord and Savior you should begin to feel lifted and connecting in the Spirit as we

connect in the Spirit as you are reading this Book. I believe that as you are reading this Book the reader's spirit will connect

This very moment is his appointed time, this is not an accident it is a defining moment, a divine set up and arranged by God, that we unite in his word together.

We are all called to Minister. This book will Minister to you in addition to being a Relationship self help book. Nothing just happens.

God desires for his people to abound in all good things the Word of God. God takes us through a transformation and has renewed your mind if you have been diligently seeking him.

God is so endowed with the scriptures, when your mind is lined up with the Spirit of God, and the Word of God is where your mouth is dominated and controlled by his Spirit which brings harmony.

Let us now receive the word of God, as it relates to what it will take to enter into the Kingdom of God.

Divine Covenant:

You may have questions about entering the Kingdom and you may ask what is needed to get there and how do you know when you are there?

Let us go to the Word to find out what God says about all this.

I read in my Bible earlier today where one must not misinterpret or alter the Bible I then prayed over my work and my Godly knowledge

that God lead and guide me and protect me to stay focused and with his intentions for me as well as for you, the reader, there is nothing that compares with prayer. Let us go forward with our Heavenly Father as our guide:

What is the Kingdom and how do I get there? This issue carries a riveting topic.

The best way to would describe the definition of the Kingdom is by saying the Kingdom can be on earth as is also the place where you will end up when Jesus returns for the Christians believers.

Allow me to address the issue about the Kingdom on earth this is probably the most significant Chapter in this Book. This is also the definition of God's covenant with man and how to get into a covenant with God.

God's covenant what does that mean?

On earth you can obtain a divine connection with God in this connection you are speaking to God on a constant basis where you are on and off with him verbally you are checking in and checking out a few times a day or using your timely discretion. Once you have followed the principals to the best of your knowledge you will have a divine connection with God this is called a covenant.

Throughout the Bible, there are Scriptures that will support the theories that God hears our prayers, he says in his word *your prayers will not be voided;* in your covenant with God the process is where you pray to him and then he answers; the answers he

gives you back is not an audible answer, his answer will be your results.

Example:

Have you ever prayed about something and although, there was no words spoken in return from God, just about when you were about to forget the prayer, all of a sudden the problem went away? That is my point; and it is where your belief comes into play.

Now that you are in Covenant with God and you have placed your faith in God allowing him to work things out for you with the difficult situations that you will encounter in your lifetime, as a believer, you should have no doubts in your mind as to God having the Power and authority to work it out for you.

Entering the Kingdom here on earth is where you have decided to become *"saved"* meaning you are in covenant with God and no longer agree to serve Satan. We are taught that good always wins over evil where Satan now has to take a back seat to you or better still he has to get under your feet.

Kingdom connection is where you are aware of being a child of God and taking the initiate to receive from God the entire and compete blessing he has for you.

Now that you have been elevated into *Gods' higher level* of understanding you are eligible for his Blessings. God has made many promises to the believers, the children of God.

Out of your obedience you can have these blessings. God will bless your works, heal your body give you prosperity. He gives

you joy, peace on earth, happiness, success, giving his abundance and the blessings keeps continuously.

He is not a God that can tell a lie.

Gods' Word teaches you to get yourself lined up with his word and to step out on faith by simply getting out of the boat getting into the deep waters; you have to get up and do something if you want something; he will be there to bless it.

When God blesses you that is a big deal it is something to shout about.

Being under his anointing

From this point, on you should have the Glory of God connected to you and once you will know that you have the *Kingdom connection* no one will be able to convince you otherwise. *It is through the Transforming* of the mind that we are to comprehend his word. There will be the unexplained when your situation miraculously changes when things begin to happen to you that you cannot explain and people will be able to see something in you they never saw before, that something would be called God living in you; now that your entire life will be changing; it will feel like Heaven on Earth.

You do not have to be rich to be in the Kingdom, here on earth however, once you apply yourself you can be sure he will anoint your finances.

When Jesus returns for his people the Heavenly Kingdom will be richer that you can imagine.

The Book of Revelations is excellent in describing what Heaven will be like? Let us take a look at the Word to see how the Bible describes the riches in Heaven.

Revelations scripture from Chapters 20-22

This will be some of the promises you can expect.

Anyone not found written in the Book of life was cast into the lake of fire. This is frightening to say the least:

Revelations also teaches about Hell.

The New Jerusalem

The walls of the mansions will be made of Jasper and the mansion is made of pure gold.

There are over 50 billion galaxies in outer space, a well known expert revealed that once you have been resurrected you will and have entered into the Spirit; you will have Spiritual access to the new earth then back to your new home the new Jerusalem where you will find Heaven. Whether this is true, is yet to be discovered.

Rev 21:2

" *Then one of the seven angels who had the seven bowls filled with the seven last plagues came to me and talked to me saying " Come I will show you the bride, the Lamb's wife."*

And he carried me away in the spirit to a great and high mountain and he showed me the great of Holy Jerusalem descending out of the Heavens from God."

The construction of its wall was of jasper, and the city was pure gold, like clear glass.

The foundation of the wall of the city were adorn with all kinds of precious stones the first foundation was jasper the second safari the third chalcedony, the fourth emerald, the fifth sardonyx, the sixth Sardis, the seventh chrysalides, the eight beryl, the ninth topaz, the tenth chrysoprase, the eleventh jacinth, and the twelfth amethyst.

The city had no need for the sun or the moon to shine in it for the "Glory of God" illuminates its' light.

In the middle of the street and on either side of the river, was the tree of life, which bore twelve fruits each tree yielding fruit every month the leaves of the tree was for healing of the nations.

"Blessed are those who do him commandments" that they may have the right to the tree of life, and may enter through the gates into the city."

Ch.5

Prayer is essential in choosing a partner also after you have chosen a partner in marriage.

Let us look at what the reading says: The creation of God was an act of God from God and was and to be enjoyed by man when we pray we are calling of God for help; you will not be disappointed with God being mindful that a partnership, there has to be at least two or more coming together, your partner and of course God; each partner must continue to share the unity.

Allow your Godly wisdom to guide you into having no regrets;

that is where your thinking process should be directed, there is an emotion that is called the looking backward emotion; another name we can give the emotion is regrets, looking backward is the cause of many feelings known as emotional distress of simply regretting something that happened years ago. Just let it go you are better of without it, and regardless to what happened it happened. It is now over and you will have no more regrets about it.

Your poor judgment may cause emotional disorder which is the direct cause of emotion distress. The key word here is no more looking back.

We can plainly see that your future will definitely not cause distress however poor judgment will cause distress.

Making a firm judgment becomes your past when applying your rules.

a. There will be emotional distresses in ones life

b. The death of a loved one

c. The loss of a job

D. having a relationship fights

e. A harmful accident

f. A divorce.

Any emotional distress can only be caused by ones past.

Our past experiences will carry the feelings of emotional hurt

a. Fear

b. Anger

c. Hate

Revenge your emotions out of position can cloud the rational judgment and the thinking process.

For example:

If a man is a fault finder, on a date over dinner, he may make some statement causing his date to assume he is directing it at her she will then make a remark back that he hates women.

The thought that she did not have any knowledge of his complete thought process made her *judgment incorrect*. When your partner has a bad thought you should disconnect and not get involved, but rather recognize that their judgment made by their statements are on them. On the other hand, there are those joyful emotions stemming from things such as:

a. Finding a new job

b. Receiving a pay raise

c. A new friend comes into play

d. You bought a new car

e. Your child makes good grades in school

f. You get to set your wedding date.

When asking yourself if you have enough love emotions; yes would be the answer.

All your desires love affections compatibility, and contentment is there waiting to be draw from.

Look for these qualities in your partner in a loving way you will be expected to find them in your life time partner; you will be spending your life there that is your intention.

Your new investigation will be the search for the articles that bring chances of finding happiness, affection and contentment.

Ch.5

Your poor judgments will rob you of the qualities of a good relationship.

Although everybody's subconscious mind is subjected to judge one another at one time or another. It is not good to judge one another. Leave that up to God.

Key: Judge you not one of another lest you shall be judge by God.

It is not your responsibility to point your finger at another if you will notice when that happens three fingers point back at you, honesty pays off, live by the Bible no one is expected to live out every word mentioned in the Bible however it gives us general and advanced rules to live by; some of the rules are defined and should be met specifically you can be the your own judge when it comes to how you choose to live out the Biblical assets in your life. One very specific Bible rule is that: *The truth shall set you free.*

The recommended time for a partners true self to appear is about one to two years if you have chosen to date that length of

time have you said to yourself "why am I with that person now is the time to get honest with yourself."

Every moment of togetherness, before marriage, is an important experience this is time you will be able to see how this person will be treating you.

Their secret inner feeling with be exposed to you in many ways even if you are already married their manner of speech will indicate such things as kindness and bitterness, whether they are over bearing and why they have been chosen as their partner in the first place; this information is not to criticize nor is it a fault finder it is intended to be friendly with suggestive information to make you think about you and your partner, as to how they will think and act towards you and treat you.

For all couples:

Godly marriages and families are the only stable building blocks for a successful society when the families in the world are restored, the whole culture will be affected, beginning with the Church.

One of the reasons the Church can be dysfunctional in one area in society is that families within the Church are dysfunctional even ex Pastors and Missionaries in many Christian denominations can't make their marriages work and divorces are rampart in the Churches.

Married people can be assisted if they read this Chapter along with the singles to discover that some of the reasons they don't get along with their mates are related to unsolved issues they had as singles. Once you resolve those negative issues; their

married life will benefit from the change. When you learn how to build on that restored foundation you will have the tools for a successful marriage that lasts for life.

Singles need to read this Chapter to learn how they can make the transition from the single life to being blended together into a life of permanent marriage then they can read the remainder of this book to learn how to keep their marriage awesome and enter into the *World of Loving again.*

In your relationship crisis you should be able to help others to create a Godly partnership, a Christian life style where they will not carry over problems into their future married life.

For the men: Learning how to *Love* your wife:

If you really love your wife, or your mate, don't change your love based on that argument that you had, rather judge her on her good merits regardless, to how she acts or what she does, your love is there forever, you should understand if she's having a bad day. You will go the extra mile for her, that's a hard adjustment for singles coming into marriage putting up with someone moody in the house there's no escape and no running home to mom. It's just something you have to do.

God loves you so much that give you enough love for both. He expects us to be loving and kind to others, but if a person isn't loving and kind, it shows that he doesn't know God for *God is love.* God showed how much he loved us by sending his only son into this wicked world to bring to us, eternal life through his death. In this act, we see what real love is, it is not our love

for God, but his love for us when he sent his son to satisfy God's anger against our sins.

Dear friends, since God loved us as much as that, we surely ought to love each other as well, for though we have never yet seen God, when we love each other God lives in us and his love within us grows even stronger.

In Matthew Chapter5

There's a portion of scripture we would love to take out of the Bible where Jesus said I'm telling you to *love your enemies* let them bring out the best in you, not the worst when someone gives you a hard time, respond with the energies of prayer, for then you are working out of your true selves, your God-created selves.

This is what God does. He gives his best, the sun to warm and the rain to nourish-to everyone, regardless to who you are.

For the men:

All the adversities added together you will be expected to even love the un loveable when they have the wrong attitude towards you. What he is expecting is for you to grow up you are trying to become victorious now live like it. Live out your God-created identity. Living generously and graciously unto others, the way God lives toward you." Ideally, marriage should not be the first place you learn to love unconditionally as a Christian, be it may be the most intense when people get on your nerves, you have to check out if you're living in a loving relationship with your love first.

If you put people in your family in the dog house and don't

let them come out unless they revert to the way you think things should go in the right way. Perhaps you don't understand God. God never holds back from having fellowship with us he always wants to be with us.

He says:

"I'll never leave you or forsake you he's not like the wives and husbands who try to get away from their mates every night of the week, filling their lives with being too busy; that's not God's way, he never needs a rest from us, you should always go to him, he will always be there that is the nature of his love. Since God himself set up these requirements for the quality of your love.

God is your provider and he will do what he says he will do the problem is that many of you do not know his word well enough to know what he is promising; he says he will supply you with the power you need and supply your needs.

We should want to rate highly in the eyes of God in your relationships; here are some attitude checks that will also help couples to evaluate themselves.

Key:

Be God conscious, not people conscious. Remember it is not who you are but Who's you are that matters to God.

Avoid being afraid of what people think rather be afraid of what God thinks learn what he thinks through spending time with him in prayer in his word. If you always do what others are expecting you will never be happy.

If you always do what God wants you to do you will be blessed, and you will have the endurance for any trial. The people who have the greatest lasting self esteem are the ones who know that God is with them.

The Lord says: *"Cursed is the man who puts his trust in mortal men and turns his heart away from God."*

Good times pass him by forever but blessed is the man who trusts in the Lord and has made the Lord his hope and confidence, he is a tree planted along the river bank, with It's roots reaching deep into the water a tree not bothered by the heat nor worried by long months of drought.

It's leaves stay green, and it goes right on producing all it's luscious fruit**. Key: don't look for a mate look for a mission and find a mate who will help you fulfill it.**
For the men:

You are the designated leader that is a difficult task there will be more significant words from God to help you with your relationship journey.

Prepare yourself to fulfill the will of God by finding the mate who God has chosen to accompany you on your mission in life. As a single, were you looking for a servant; someone to fill your unfilled intimacy life or were you immersed in the purpose of God, and surprised with joy by the life partner he sent you?

Things the male partner must know about his wife or his single partner. One of the most life-changing things you can do

is to excel is giving. Especially to your wife or partner because you represent Christ and her represents the Church God is always giving to both.

In addition, to personal gifts, there are additional things every serious man of God should give, and that doesn't mean just giving her crumbs off the table things; give her the full meal from the table of God or better still give her the entire restaurant.

That is what she deserves for allocating her time and effort with you being the awesome male that you are.

Let some of your giving be in secret, and let some of your giving be at times when she knows you are not giving out of something you want from her in return. She obviously will not feel loved if you are always too busy for her, if you are disappearing out the door all the time having something to do all of the time.

You should be able to just look at her to see, if she is deficient in some way. Taking time out to serve others is always going to bless them.

For the men:

God will change you; he will show you that your time is not yours. God wants you to get it right with your mate it will take you time to get it right. You are designated by God to be a leader for your family, a great deal of responsibility goes with that. It is of utmost importance that you know your Christian obligations to God and to your family. Society is depending on you. There are far too many single homes where the children have turned to the streets. They are living in despair; if only the parents could have

decided to stay together and make it work out for the sake of the entire family thousands of children would and still can be saved.

There are ways to invest into your partner:

A good example, is to pray together everyday, study the word together, go to Church together, doing activities together, if married go to bed together, watch Christian networking together, you should open doors for her pull out her chair for her when you are out to dinner, help her with her coat and with grocery shopping, work together and make her meals that you prepared.

Many men feel that if they earn the money, it is rightfully theirs to control they don't realize that one of the reasons God has allowed them to have money is so they can give it to her, the wife many women are humbled at the idea of taking money and spending it on themselves. Give her a check and have her put it into her account for herself.

When you sow into your relationship you will also reap from it. Often times, men will reply that that they do not understand women could that be because you do not have a listening ear?

Through out the Book of 1Corinthians and 11Corinthians. There are keys. The Bible says: Husbands love your wife, even as Christ also loved the church and gave him self for it.

The problem as to why you do not understand her problem is that you are ignoring her you don't have a listening ear it is a sin to ignore someone God has told you to cherish. It is not that difficult to understand.

The woman came out of the man; therefore she is like the man.

For the men:

Here is a description of the way women are created: In the Book of *Genesis*.

"And the Lord God caused a deep sleep to fall upon Adam and he then took one of his ribs and closed up the man and made woman and he brought her into Adam and says this is bone of my bone and flesh of my flesh."

The Bible says in *Corinthians* that *a man should leave his father and his mother and cleave to his wife and they shall be of one flesh.*

Women open themselves up and are vulnerable to men when you fail to know your partner (wife) this will be your sin to ignore that responsibility, it is noted that you do not neglect your responsibilities to her, reflects a form of abuse so do not ignore and do not hide your feelings.

Get your help from God.

God shows us his heart first, God exposed himself first and we took advantage of him most women don't do that your wife will expose herself and talk to you out of her heart you must do the same in return for her.

For the men:

The next suggestion would be to train yourself on this one, listen to her when communicating there is a two way communication system that takes place, even if you are not

interested in what she is saying if she is upset or complaining about something, you should show her that you feel bad about that situation and you care.

Your wife should accept your genuine confession and repentance in return.

The break up comes when someone wants to just quit due to you not wanting to change and you are not willing to make the sacrifice to respond to her needs.

You will have to learn how to say I am wrong, I made a mistake, I am sorry it was my faults, never falsely accuse her you should never play the blame game bringing accusations into your relationship, whether falsely or not.

The Bible says that God has given us the *Ministry of Reconciliation* in the same way he was in Christ. Reconciling the world to him self. God's reconciliation effort is what is called International Negotiations a unilateral effort God alone did everything necessary to provide the means of coming into harmony. That is what happens in your marriage when you give your wife a listening ear, and you make an internal decision to carefully consider everything she says without prejudging it or trying to make yourself come out on top.

Men often times believe that their world is far too complicated or sophisticated for their wives to understand some don't even want their wives to know about their jobs.

There are six more areas that I want to address then there will be a quiz that will test you to test your awareness issues regarding

your relationship. This quiz will test how compatible you will be with your mate.

I have allowed the world to define me however; I am coming out of that caring mode and going into pleasing my Holy Father in the following ways.

a. I am taking my life back

b. No longer will I be victimized

c. I have adopted a new way of thinking

d. I am noticing a change happening in myself

e. I am now ready to invest into a quality of life

f. No more waiting. The time is now

g. I will not be defined by the world?

Most of society is guilty of this one to some degree concerning oneself with what others think about you, how you look, how you act; and many other related issues; rather than concerning ones' self with how we are looking before God.

The Israelites in the Old Testament Bible took 40 years to figure out God's plan to free them, was actually supposed to take only a few weeks.

Why? You might ask: Because they were not listening to God nor were they living out of his obedience, it appears that there was too much worldly living they were just living it up doing those things that distracted them from God's directions.

Perhaps you can visualize listening and giving to your mate during times when your relationship is great and you're excited about going to her but what about when she is uptight at you? What about those turnoff's that you might get?

That is when things should really go into action some men might say "you don't know what I have to put up with." Fault finding that he has to take care of everything and "All she does is just sit there all day."

Giving is to gain, the two of you are investments, you will need to see her through the eyes of Jesus.

For couples:

The leadership role is the greater being the C.E.O. of your family is a tremendous responsibility requiring you to get all the help you can muster to pull this one off. How do you know if things are going right? Ask your mate.

You as well as your mate will begin to feel a sense of peace about you as well as you will notice that you are feeling your joy is coming into play there will be noticeable change in your life.

I have taken I will no longer be victimized; control of my life.

Any time you are feeling vulnerable, tired, or weak; those are times when Satan can take advantage of you. Satan is so powerful that he is working on you when you least expect it. No one has to fall in being the prey of Satan.

Here are a few examples how to rid you of Satan:

You can always *'speak outwardly'* it is permitted to tell him to go' that you will not serve him, that you are taking authority over him that you are sending him back to the pits of hell where he came from. And bind him out of your life. God always wins out over Satan

Once you have Satan out and rebuked and bind him off your life in Jesus name you are home free. Just know that Satan will return repeatedly therefore this procedure will continue. Have the freedom to move about you are your own worst enemy, it is fear that causes you to run from yourself many times. Therefore, it will require a new way of thinking to correct your past down falls.

It is similar to dieting and then going back later and putting those pounds back on, the reason you put the pounds back on is because there was no change in your obsession to overeating. There was a need to change the eating process to condition your mind to no longer crave the over eating. Over eating is another method of being Spiritually manipulated by Satan, it starts in your mind, whenever you are thinking about eating when you are not hungry or over eating those are the ways of the wicked. The time is here and now you can no longer tolerate what Satan has placed out there for you. How God's anointing works for you.

God brings your greatest blessing and you should be grateful that he allows you to reach out to someone who is having a crisis in their relationship, or in some other area. It is an eye opener and it works when you are given to the Spirit when the Spirit is flowing in your life, the things that are not so become so.

Stay calm, recognize that your adversity is temporary, stay in obedience, serve one another, get out and do activities together, make peace and focus on building a Godly relationship, remember it is all about pleasing God.

Getting focused:

The more you are focused on self improvement, the more you will invest in it, the more time you are spending the better the quality of life will be for the both of you.

It would be great if your steps towards finding your victorious self become your first priority; when you are interested in something your career or whatever it might be, it is where you want it to work for the better; that is why getting focused is where you should be at this time.

Staying calm and cool is a wonderful and effective way to over come your obstacles along with being in the right environment before you can expect your life to change. Get rested and focused timing is everything your stage is set.

Just when you thought that negative situation was about to take you out; look at what happened you got out of it and it turns out it was not as bad as you thought it would be; nothing lasts forever hang in there and the storm will soon be over.

Do unto others as you would have them do unto you. The Golden rule.

How do you want your partner to treat you? Perhaps like royalty? There is not a sane person on earth who does not want to

served, just know *that it is better to give than to receive.* It is meant for us to serve each other, there has to be a two way street in you giving, if one of you is out giving the other on a much higher percentage, there might be a cause for resentment therefore you must both give to each other on one accord.

There is an abundance of law and order to comprehend.

Get out and enjoy each other. Life is such a precious gift it is meant to be cherished and enjoyed you only have one life to live and then this earthly life will end; until Jesus returns, therefore it should make good sense to find enjoyable ways to enjoy your life, it is too precious to just throw it away, being bored or complaining about the negatives in your life. Make an effort immediately to begin to sow into the pleasures of life. Make the devil angry by loving each other again.

There are those people who never realize how to identify their gift; and do not realize they have a gift understandably so you could be a talented singer of no earthy good until you step out in faith and expose you talent, that would other wise never be discovered. Your gift has been given to you from God's grace to help you identify it, one has to continuously pray about it asking God to reveal to you what your gift is or ask someone what they see in you that could be identified as your gift others can see things in us that we cannot see in ourselves many times.

There are those people who know their gift, when they apply it into motion by realizing that your gift is your motivator and your supply comes from God, realize that you will never become empty,

when you are using your gift properly; how will you know if it is properly being exerted, you might ask? You will know it because your life will become revitalized you will have the assets you prayed for, where God feels your needs. It may not be obviously notice instantly, when God is behind the scenes, but slowly and surely, God is working it out. Sometimes it is silent while God is searching for alternate ways to turning situations around while he is opening doors and closing doors as well. Suddenly, all of a sudden you look up and your life has been transformed into becoming Christ like, positioning you and getting you in preparation for his Kingdom and his glorious return.

That definitely means that things will have to be in order.

In his Kingdom you will find order.

As you are beginning to embrace and enjoy your life, there are two type of people that we have before us, some people are home bodies and other love the outdoors; as you are enjoying the pleasures of staying in doors naturally, there comes a time when it will be advisable for the two of you to step out and find activities that you can both enjoy especially if you are single if you are always indoors you will have less of a chance to get noticed by a potential relationship match for you.

There will be a continuous process where one finds himself investing into the quality of life the quality of life means that you do not just want mediocrity to just get by any longer, rather soar with the eagles. By now you have probably figured out your gift

and you are taking your first steps into initiating it to work for you. *Congratulations!*

For the love of money:

Often times, the expression comes from people saying they are not materialistic, they find it a waste of time and they would rather invest in the more engaging things in such as education, career, reaching goals, and find self fulfillment. Then there are those who happen to like the material things of life, a mixture of the both in life will capture the majority.

One does not have to sacrifice one for the other, however you can choose to have them both as long as you do no serve money, it is fine having great wealth and riches as long as you are not being ruled by the wealth and the riches; your Bible warns not to fall in love with money and declares it the root of all evil.

We are seeing examples of people who will try anything go anywhere and do anything for money, that is a direct insult to the Bible being greedy for nothing is the way in which you should handle your lifestyle.

There is nothing better than achieving a life long marriage that is working. That will prove to be most gratifying for the both of you. That will top all relationships.

What could top that here on earth? Loving someone who loves you back it turns out to be a case of sheer bliss and let's face it bliss is what you are trying to get incorporated into your life.

It won't be easy, it will require hard work, and knowing which

button to push and which one not to push with your partner. Once you push the wrong button; you will get a reaction that will teach you about that button not to go there and pay special attention to the button that you are suppose to push, the one that allows you the freedom to becoming creative, the button to push would be of course the *Love* button you want to excel on that one; that could only reap fulfillment, joy, and peace that you deserve in your life.

You are adorable; I know because God made you and he doesn't make his children to be foolish. No more waiting now is the time you have waited long enough.

When assessing your time. It is perplexing when you just sit there, timing is a quality of life; yet to be discovered and lived. There is financial growth to be harvested; there are people to see and places to go.

Many times you will need motivation to help you relate to your calling; together you must keep each other encouraged we are to serve one another keeping the dream alive and keeping the flames of life's fire burning.

It is unanimously agreed upon that you have a tremendous job to do when you are doing God's business not your business but his. God's business comes first and over and above your relationship, it is all about him and pleasing your Heavenly Father being the major the focus.

Once you stop trying to fix your issues your self and let God have his will and his way, this will allow you the freedom.

Chapter Six Finals

Summary

As you put together all the articles of data you have in front of you there is no reason as to why you cannot coordinate your life in a manner, where the outcome is defined as a victorious relationships.

Let virtue flow from you, as it flowed down from Jesus when the unclean woman touched the hem of his garment; virtue flowed from *him virtue means power in Greek.* Are you virtuous? One needs to place much value there; ask God to purify you and to renew your mind.

Singles should never dwell on intimacy related thoughts, but rather turn your thoughts over to Jesus and his standards. Jesus says whosoever looks at a woman with lust has sinned and committed adultery within his heart. Getting a grip on your self

control allows your mind to be line up with the word of God. Get into the Holiness habit if you are single so that by the time you are married it will make life easier.

You will need a clean heart *in Psalms* it says; *blessed are the pure in heart for they shall see God.* Train your mind to obey Christ, when you are ruled by your wrong thoughts, you are captive to your physical drives; either in premarital intimacies or adultery where your mind prefers something that was intended by God to be sacred in marriage.

Your impurities before marriage begins to destroy your marriage before you've even said " I do" even if you never act on a thought, it will infect your marriage and your children if you don't kill it off; you can't defeat the devil in the world if he's having his way in your heart.

Finals

Living in the fear that you will be judged by God for what you do includes what you do with your wandering eyes *if your right eye causes you to sin pluck it out and cast it from you, for it is more profitable to you that one of your members perish than for your whole body to be cast into hell.* Intimacy is the seal of a lifetime marriage covenant not a recreational pastime if you have had extra marital affairs outside of marriage, or if you still fantasize about it you need to have the fear of God come upon you. You are dabbling with spiritual death.

When you repeatedly sin, it says in the Book of Romans, God will eventually stop warning you and let you go into all

kinds of degraded behaviors, with dire circumstance, that is why most people don't feel any shame anymore about pre-marital and extramarital affairs.

It is not that it has become acceptable with God. It's just that they cannot hear from him anymore, what an awful price to pay for just a few minutes of pleasure. The Bible says *"Since they didn't bother to acknowledge God. God quit bothering them and let them run loose."* And then all hell broke loose. Keep a constant awareness that you will answer to God with everything you do that is related to God's sensitivity will keep you from such sick behavioral characteristics' of sin.

In the Book of Joshua:

I am reminded of the story of Moses, who later died and his son Joshua took over his position as a leader of the Israelite people in that land. Moses was assigned by God to lead his people to the Promised Land, the Israelite people were attempting to get across the red sea where they could find their new found freedom. The Bible tells us that had they listened to the Word of God and followed his instructions, the trip would have lasted only a few weeks, but out of their disobedience the trip lasted forty years as they kept going around that same mountain. That is incredible they kept getting it wrong and having to repeat it around and around they went around the same mountain.

The Bible teaches us in the Book of Corinthians that *fornicators will find themselves in the Lake of Fire.* That is enough said there is nothing else more alarming than that statement. If you are

having ungodly relationships outside your marriage, either you are not a Christian or you are going to Hell, unless you change or you are a Christian and you have greatly sinned when you fall back into inabilities to repent from sin, some would say you may still be saved and going to Heaven, but you are definitely not acting like someone who is a about to return with Jesus.

It is about finding your love, your lover and someone who you can reach out to love. It is always better to give than receive so it is a matter of finding first someone whom you can give to them your love.

One of the important major principals of truth is when you give you will receive. The Bible says, we *will reap what* we sow in return all good things are taken into God's consideration. He is God and we are supposed to belong to him therefore, we have no choice but to let him figure out who has been living in obedience and who has not. It is not our business to Judge another's actions that will be taken care us for us.

When people look at you they will see God once you have allowed him to take control of your life; ask yourself what Jesus would do if he were in this predicament that is a way of knowing the enemy of lust or temptation is there.

Finding love:

There are three known types that include: The love between you and God is the agape love which is referred to as the greatest love ever known, it is where we find your love for God, a heavenly finding God's infinite glory: type of love when you are taken up

into the spirit in praise and worship and we are connecting in heart and in spirit with God.

It is a beautiful place where all is well and the joy of the Lord has come it is a hear felt place where all is good and everything is about him, it is where, even though you are still not made perfect we have come a long way and you are much better than you were before. Agape love is defined as to be the infinite non comparable love of all opened mouthed. There is the love of God, which is a Spirit filled love that encounters only the spiritual aspects of love.

There is the love of a man and woman for each other; that brings out emotional joy. This love is the love of creation. This type of love identity's how we all got here on earth, where there is the sharing of the body and birthing of new beginnings, combined with Spiritual love, this is a dual type love.

There is the love for your children and your parents. It is also similar to the love of God it is Spirit filled love and comes from the heart and concerns itself with the preciousness of God's gift and connects you with the Grace of God beyond and above you own comprehension.

God hears our prayers: God says in his word that *your prayers will not return void* therefore if you are opened mouthed and speaking outwardly he will hear you.

I was listening to a well know Pastor recently, who has extensively researched angels; in his sermon, regarding the angels in the Bible. I found it interesting that angels are encamped around and about you there are legions of angel around us. We

hear about our guiding angel that expresses the angel that leads you and protects your conscious being. That small voice that reminds you that those awful things you did were not good for you; what a blessing to have a guiding angel to usher us into their presence.

To listen to your prayers and lead you to a safe answer to your prayers you don't necessarily always get what you ask for, *if what you are asking for is not in his will for you*.

For example:

If you pray to God for example, to give you great wealth, and you request it, immediately, your chances of getting that wealth will be next to impossible. The scripture that says ask and ye shall find, is referring to that which is intended and in his will for you, that which is reasonable and obtainable. There are miracles, of course, I would define your miracle as something outside the normal blessing of God. A special blessing is where you have earned his forgiveness and he has found favor upon you, placing a miracle on your life. A miracle is where God is granting you his divine favor.

The enemy gets in through the soul which means your mind, your head, into your thinking process; therefore, you will have to use a method that will block him or rebuke him, by not allowing him to infiltrate your mind. If you don't comprehend anything else in this book please get this! **Satan enters and gets into you through your mind (*the soul*) realm,** then he goes to work of

fulfilling his mission on this earth that is: to *kill, steal, and destroy you.* Satan causes you to speak about doubt over you life.

Once he gets into your mind; your thinking channels and convinces you that you are going to die through sickness or some lack or other treacherous lie, all of the lies he has available; he will try to convince you of his lies; if he sells himself to you and you buy into the lied; you will become his prey. The good news is you are empowered to **resist the Devil and he will flee.**

By now you know that the Bible teaches that Satan's purpose on earth is to steal, kill, and destroy that is his purpose down here on earth. That is all the more reason you will essentially, have to identify his works, keep an eye out for him; sometimes it is difficult to tell the difference between the two God and the Satan the Devil because Satan is very manipulative and clever; however you will not be distracted when he comes to you in disguise, there will be a distinct difference between the two once you are equipped with the word.

Key:

The truth will set you free. Why does God allow you to continue living? Because it is not about who you are it is all about who's you are. Your life is predestined before you were born.

That statement has a great impact being about who you belong to; makes good sense; it is not about whom you are or what line of employment you are in; but about *who's* you are. One must decide to belong to God you must demand to Satan enough is

enough tell him to take his hands off of you, your life and the life of your family. You belong to the Kingdom of God

One might ask "Why does God allow us to go through tribulations?" I have two well known reasons:

One is because of your own disobedience you fail to heed to the truth and decided to venture into life on your own without God you cannot dismiss God from your lives. The enemy is far too great and the temptations are even greater. You must stay in line with God.

The second reason is that God's word promises you that there will be tribulations, it goes with the territory, there was tribulation on God and his son to give his son up to become crucified. Can you imagine the tribulations upon Jesus when he walked on the earth? The adversities that he had to endure?

Tribulations are something we will have to endure. *There is still good news*

You can eliminate Satan out of your life and cast him out and bind him out in the name of Jesus by speaking outwardly to him. And say it ending the demand by ending it saying "In the name of Jesus."

Once you are equipped with the word of God you will be equipped with a type of radar alarm a sensory telling you the enemy is near, that will be nearly all of the time, if he can monopolize all your time he will do that it is the Christians responsibility to see to it his mission is now cancelled.

To lighten up the mood:

Love is our most powerful emotion:

The love of man and woman which will take you back to Adam and Eve where it all begins. The love of your children and family and other people is the third.

The love for man and woman is closely related however, if not the most powerful emotion that is available. The love between a man and a woman show tremendous and powerful affection for each other and carries the producing seed with it. It is about sowing seed and the reproducing of that seed that carries such significance in identifying what makes the world go around. That sowing of the seed type of love is how we all got here.

Intimacy and love are different in many ways and yet they have a common ground; too many times the two are erupted with misunderstandings.

When a couple are in love there is a glow about them the guy will carry himself with his chest held up high, he feels macho and is in touch with his male ego; men are egotistical and feed off their egos when he is in love it brings out the best in him.

If you find a man who is truly in love with his partner along with God, you have found a man of God and there is nothing better for the female than to know that she is in the hands of a man of God to lead her and to be loved by him. Being in love is a state of mind that cannot be compared, when it comes to the glory that being in love will bring.

This is ultimately what all couples are trying to achieve. There are thousands of singles in society who are relentlessly still searching for love. Some of them will find love. Some of them may never find true love although believe that anything in this world that you want badly enough you will indeed find a way to get it. *To the singles*: if you are searching for love and not finding it, continue to persevere, and line your search up with the word of God and you will surely find the love of your life don't give up and don't let the enemy discourage you.

It is through finding your gift and your creativities that God has given you so that when applied you will get better at your game. The devil is a liar and causes you to doubt. When doubt occurs you begin to think you are not good enough, just know where it is coming from. You can find a partner you can secure a *victorious marriage and you can love again.*

There is a saying from many that; never again will they marry; those statements are words from the discouraged. Anytime you burn the bridge from where you came; disconnects you from growing in God.

The discouragement has set in and the negative feeling that marriage is something they will never go back to; leaves the implications that these people are wounded. All will come out with having some type of wound, whether it is emotional physic logical or physical. Life goes on however, the best thing to do about it is to pick yourself up brush yourself off and get back out there; this time get it right no one else can live your life for you; you have to be strong and use the Christian methods to come out

victorious; there is no other way out that will work in a positive way for you.

When you have been seriously hurt by another person you may not be quick to dust yourself off it might take time in fact, you should take ample time to heal, whatever length of time it takes that is necessary, before you get back out there.

Never let go of you faith, you can find true love in spite of your reasons why you cannot not; look at those reasons why you should; and there are many reasons why you should; and why you can have a loving relationship.

There is the love of your children that can be the most inspiring blessing along with your grand children, is where you can find the glory of God they are angels in your eyes most of the time, you don't see many of their faults only how precious they are; when you look into their big bright innocent eyes you see the works of the Lord in them and you should be forever grateful to God for giving you those children.

You are always indebted to God there is no price tag placed on his blessings you cannot raise enough money to pay for all God's Blessings.

He gave you life he created the world around you, he says in his word that he will supply your needs, since all the money belongs to God. He allows you to live in his creation and blesses you out of your obedience to him, each day.

Every day is an astounding blessing, that God allows you to live your life is a blessing and should not be taken for granted or

hated, if you can see and comprehend your purpose for living; you will have more insight into how wonderful life can be. It is through a negative malfunction that causes hated to enter. Usually, hate mongers start with hating themselves first, later it is passed on to the hatred of others.

Hate starts when the child is born and taught to hate others because of their differences. Until love is found there is no possible way of finding a fulfilled relationship in marriage.

While the believer will be rejoicing in Heaven the choice should be evident it shouldn't take a brain surgeon to know whose side you should be on however there are still far too many lost people in the world who are still allowing Satan to rule over their lives.

It is a blessing that we have our Christian Television Networking for us in this recent decade that allows the Ministering to flow around the world while you view it from the comfort of your home. Recently the Word of God has been allowed in areas such as China which is predominately a Buddhist and a non Christian country.

The Bible teaches that once you know the word of God you will then be held accountable for your believing by faith. If you have never heard about Jesus and how he saves you, the unknown cannot be held against you.

Let us take a look at how the ladies are to conducting themselves.

A single lady can remain a virgin and a married lady can keep herself out of adultery.

Oftentimes, when God speaks of his people's unfaithfulness he uses the terminology of the promiscuous lady he calls those people harlots who are suppose to love him and serve him but are running after other Gods and their own lust; the word harlot means simply that a lady has had an adulterous affair outside of her marriage. If that is such an awful encampment to God, why would you want to be one voluntarily, if you say you are a believer?

If you are a single lady there is only one person of which you should submit your body and that is to God.

He will respect your body as a body sacrifice *I urge you therefore, brothers by the mercies of God to present your* bodies hold *and a living sacrifice to God* which is your spiritual service of worship.

God wants you to wait for someone he sends you to marry you someone with the character of Christ as you wait on God and refuse to yield because of pressures that are brought on by others, you will not only protect yourself but you will also be growing closer to Jesus, and increasing in your Christian walk.

In recent times, the out look regarding intimate behavior outside of marriage is changing for the better; on a broader scale and is now being looked upon as being even more degrading than ever before. That sin is carrying seed from the pits of hell therefore, you must just say no to sin.

There are diseases that are transmitted from partner to

partner, you should ask yourself if it is worth it for a few minutes of so called pleasures? No, it is not worth it, God manages to forgive your sins however, why take a chance on catching some un Godly disease that could cost you double in two ways you could pay.

Through a horrible disease brought on by a transfer of venereal disease or from just not getting your forgiveness from God and allowing oneself to go to hell as a final result.

When you marry, you restore that oneness of body, soul, and Spirit that exists when God blessed man with the woman still inside him the two of you together become unified to fulfill his eternal plan, and your relationship to one another and to God is already established in Heaven.

There is wholeness about you when you are called to be together and you walk out that wholeness everyday in sacrificial love.

When you are born again there is a transformation period that you will enter you are now married to God and enter into his Kingdom in the Spirit, he says in his word *if you ask he will answer, knock and the door shall be opened unto you. Seek and you shall find.* Being saved is ritual where you take your prayer to the throne of God and repent from your past with truthfulness and give it to God and ask for forgiveness, requesting that you want to live for him now he will not turn you down he says he will accept you just as you are.

Adam and Eve were presented by God. Eve was a special design made especially for Adam.

When she is concerning herself with her most exciting day her wedding day, she is thinking of the wedding as an event designed to focus on the marriage and her new groom and not on her self; can you imagine the man handling the details of the wedding let alone the man actually wanting to do it? According to another relationship authority who says: "marriage was the Biblical model in the beginning and will be the same at the end marriage has been the works of God. "

From eternity to eternity in the life to come, it is the Bride who makes herself ready, but it is the Lamb of God who has set everything in place for her to come. John heard the multitudes in Heaven saying, *"Let us be glad and rejoice and give him glory for the marriage of the Lamb has come, and his wife has made herself ready."*

And to her it was granted to be arrayed in fine linen clean and bright for the finest and the most exquisite clothing available is the righteous acts of the saints.

The Bride, generally takes care of the necessities and makes herself ready, it is very similar to getting prepared to be the *Bride of Christ* when God enters into a covenant when you are born again, that is the beginning of your espousal period. From that point on you should begin preparing to be the Bride of Christ.

When a lady's expectations to marry is fulfilled and accomplished she gets seriously excited and prepares herself for

the most exciting day of her life, she goes out and makes all those special arrangements, including the wedding dress which is the star of the event along with all the necessary arrangements, she need to get herself adorned for her groom and allowing herself to look her very best being more beautiful than ever. When the groom views his bride for the first time he is floored at how beautiful she looks.

Your marriage can be the best of times and it can be the worst of times. Making the plans would be the best of times the honeymoon is tops of the events.

For example:

There will be those worst of times; one being child birthing pains that is a worst of times for all however when that little bundle of joy comes out it is now the reverse. The worst of times is the negative times where you are finding disillusion, despair or sickness. Your vows are to stay there in the marriage through sickness and health until death parts you two.

In Genesis 2: God speaks about marriage:

As a Christian, you should be paying a great deal of attention to your preparation to be united with Jesus, when he returns the return of Jesus is really what life is all about, it is why you are making all these arrangements to show yourself approved by God so that upon his return you can go back into the sky with him to be united with him as one family. That wills the most important day.

Chapter Seven How compatible are you?

Quiz:

Let's have a little fun!

Comparing your assessments:

Answer these questions then let your partner answer. Using from one to ten points with the ten being excellent. Grade yourself then let your partner grade themselves, then compare answers. You will be finding words of wisdom and a list of tips to help you in your leadership.

How important are these listings to you? With ten being excellent 1 2 3 4 5 6 7 8 9 10

Being faithful

Spending quantity time with your family

Staying focused on your partner's needs

Being on time

Being a relational steward

Having a neat appearance

Helping with shopping

Budgeting

Doing long term financial planning

Taking care of your possessions

Arranging for home maintenance

Spending quantities of time with your family

Attending special events

Being a good provider

Going to Church

Keeping the marriage or relationship interesting

Maintaining integrity

Being honest

Asking for forgiveness easily and quickly

Mentoring others with the unselfish goal of making them more successful that you are

Preparing for the future with Christian teachings

Guarding your tongue

Being complimentary your mate

Being careful never to lost your temper

Building up your family with positives

Never gossiping

Keeping your word

Keeping work ethics

Planning for vacations and social activities

Finishing a task

Relationship with your mate's family

Dealing graciously with others

Handling of money

Giving of your time

Taking care of business matters

Keeping your promises

Being respectful and pleasant in your relationship

Being a good provider

Being considerate of other family members

Mentoring others

Communications

Focused on doing the right things

Showing Christian leadership

Never gossiping:

These are some of the basic leadership listings, as you can see, it will be difficult keep in mind that hard work starts with your attitude.

Let us now go to a test to find out how well you know your partner, now that you have read all the facts and looked at the many examples relating to human behavior. I hope do not say that you regret having chosen your partner after marriage there should be no surprises.

There is a great deal of contentment when you know you are compatible, you will not be afraid to partake of the enjoyment and you will be a part of joining in with the engaging pleasures of life.

When purchasing this book: You can send your relationship question for our free advice analysis about your relationship issues.

How Compatible are you?

Grade yourself then let your partner grade their scores then compare your answers. Grade between one and 10 with ten being excellent.

1. How would you rate your partner's ability to relate to your family?

2. How comfortable does your partner make you feel when you are around your partner?

3. How you considerate of your partner are you?

4. How much does your family accept your choice in your partner?

Use the one to ten grading system 1 2 3 4 5 6 7 8 9 10 with ten representing excellent.

How important are these listings to you?

Looks

Manners

Education

Choice of entertainment

Arrogance

Alcohol consumption

Vulgar language

Alcohol consumption

Even tempered

Socially accepted?

Intellectual

Over all presentation

Rudeness

Dress

Vocabulary being well versed

Loyalty

Punctuality

Interaction with others

Intellect

Education

Drug consumption

Health issues

Bad Habits

Answer these with a yes or no to each of the following:

Would you consider yourself a picky person?

Is your partner a picky person?

Do you find fault easily?

Does your partner find fault easily?

Who has the quickest temper you?

Does your partner have the quickest temper?

Do you blame others?

Does your partner?

Do you go out partying with others without your partner's consent?

Does your partner go out partying with others without your knowledge of it?

Do you hide behind lies?

Does your partner hide behind lies?

Do you use curse words?

Does your partner use curse?

Do you manipulate your partner to get your way?

Does your partner manipulate to get your way?

Do you find yourself helping others?

Does your partner help others?

While dating does your partner comes first?

Does your partner put you first in a date?

If you are engaged and wanted to date another would you?

What about your partner?

Do you like yourself?

Does your partner like their self?

Are you easily embarrassed?

Is your partner easily embarrassed?

Testing

Are you easily bored?

Is your partner bored easily?

Are you considered to be a successful person? In what way?

Explain? _____

What about your partner? _____

Do you believe in God?

Does your partner believe In God?

Does it matter if your partner is not a believer?

Does it matter with your partner if you are a believer?

Do you hang on to the past negatives in your life?

Does your partner hang on to those past negatives?

Do you trust others?

Does your partner trust others?

Grade yourself then let your partner grade for their self then compare your answers

Grade between one and ten with ten representing excellent:

1 2 3 4 5 6 7 8 9 10

Are you opinionated?

Do you yell or fight or fight?

Do you have the ability to discuss your problem?

Are you great peace maker?

How much do you trust your partner?

How truthful are you?

How much does your opinion matter?

How demanding are you?

How considerate are you?

When your partner calls how happy are you?

How good of a listener are you?

How well do you express your complaints?

How important is marriage?

How degrading would you say your partner has been?

How well do you handle stress?

How would you grade your entire relationship?

Testing

Negative traits: How you handle negatives.

The next exercises you will be choosing the answers that describe you, then let your partner grade their answers, then compare answers. Circle your answers.

These are negative traits:

Procrastinator

irritating

Boring

self righteous

Lazy

Selfish

Very particular

Controlling

Unclean

Sloppy

Militant

Proud

Passive

Clean home

Crazy

Fault finder

Conceded

Rude

Dumb

Family Affairs

1. Let's say if you were with your family and someone asked you to do something you did not want to do how would you react?

a. Make an excuse not to participate

b. Watch the others get involved

c. Leave the scene until the others are finished

d. Complain to your partner after you were alone

e. Enter the Spirit of the affair

2. When taking your partner to meet with your family is this person?

a. Withdrawn

b. Shy

c. Friendly

d. Scared

3. When you suggest that you will be spending time with your family what kind of response to you get?

a. Reluctant

B. Eager

4. When you are ready to return to your home to a family visit does your partner (circle your answers)

a. Find fault with your family

b. Look forward to the next time

c. Want to continue to go with you

d. Refuse to return there

5. Are you proud to introduce your partner to your friends and family? (Yes or No)

6. How does your family act when your partner is there?

Explain:

7. To solve a problem you are both in disagreement how would you solve it?

a. Fight using every topic every topic you think that might allow you to win.

b. Discuss the topic, presenting your views

c. Argue until you win

d. Yell loudly

8. Let's say you saw yourself as loosing the argument how would you then react? Check all that apply

a. Cry

b. Pout

c. Break, throw or slam things around

d. Lock yourself in a room

e. Create a scene

f. Involve others

g. Slam the doors

h. None of these apply

9. Do you feel that because you are female or male you should win all fights?

Activities

Let us now take a look at your activities that you will be sharing. (Rate from one to ten is your greatest love for the following: 1 2 3 4 5 6 7 8 9 10)

Skating roller or ice

Going to a picnic

Swimming

Yard work

Hiking

Volleyball

Boating

Skiing water

Cross country skiing

Taking walks

Dancing

Other _____

Is it possible that you can learn to like what your partner prefers to do? Yes or no use

How soon can you get started? _____

Anger management

Answer with a yes or no

What do you do when you get angry?

Do you throw things?

Do you yell?

Do you argue?

Do you leave the premises?

Do you curse at your partner?

Do you slam the car door?

Do you break things when you are angry?

Do you fail to listen for their explanation?

Do you start fights?

Do you falsely accuse?

Do you play the blame game?

Do you continue to bring up the past?

Do you talk against your partner's family?

Do you stretch your imagination with suspicion?

Do you practice any type of negatives against your partner?

Explain _____

This is a list of places and activities that you will be sharing.

You may grade yourself with a number between one and ten being you greatest likeness.1 2 3 4 5 6 7 8 9 10 Next, exchange answers with your partner.

How important are these activities to you?

Parties

Talking

Reading

Art Museums

Dances

Church

Quiet time

Sex

Bible study

Home gatherings

Eating out

Movies

Traveling

Other explain _____

How often would you prefer to go out to eat?

Once a week; twice a week; once a month; every day; never?

How often do you attend church?

Once a week, twice a week, once a month, seldom, never?

Expenses

How well do you agree on money issues?

Do you prefer to share the bill when you are eating out?

Your partner's answer?

Should he always pay for dinner date expenses?

Your partner's answer?

Should he pay for a portion of her expenses such as her bills?

Your partner's answer?

Should she have to pay bills and expenses 50% of the time when married?

Your partner's answer?

Should she loan money out to him?

Your partner's answer?

Should he loan money out to others? How much is too much?

Your partner's answer?

Are you upset with spending on a good amount of money each weekend for dinner?

Your partner's answer?

When purchasing a car how much is too much to spend where should you cut off the price?

Your partners answer?

How much is too much to spend for a home?

Your partners answer?

How much is too much to spend on a special event dress?

Your partners answer?

How much is too much to spend on a men's suit?

Your partners answer?

What is a fair amount to spend on a night out on the town?

Your partners answer?

How do you feel about investing your money?

Your partners answer?

Intimacy issues:

How important is intimacy with you? Explain?

Your partners answer?

Offenses - how well do you handle them?

Rate each response based on the level offense it creates with you. Ten representing very offensive 1 2 3 4 5 6 7 8 9 10

Your partner smokes marijuana?

Your partner receives calls from an ex-lover from time to time even though they have no children together.

Your partner has a secretary or assistant of the opposite sex who is striking good looking, that you did not know about?

Your partner's child from a previous marriage yells at you?

Your partner's best friend comes to take your partner out twice a week?

Your partner has insufficient funds N.S.F checks returning?

Your partner makes a large purchase without consulting you?

You find out later that your partner has a child that you knew nothing about?

Your partner keeps old photos of old girl or boyfriends?

If you are out dancing and your partner is asked repeatedly to dance by another?

If you are working and your partner has neither job nor helping out around the house?

You overheard the partner's mom speaking against you?

Your partner goes out of town for three days and forgets to call home?

Your partner expects you to go to Church alone?

Your partner has a personal work out exercise coach of the opposite sex that is gorgeous that you didn't know about?

Your mate forgot to pay the electric bill?

Your mate is still married to his first love never divorced and didn't tell you.

When comparing your answers it is advised that the area where there is a discrepancy is your area of concern. You can easily identify your differences by comparing each question where they greatly vary.

Please write in detail your answers below each question.

1. What is it that you like most about your partner?

Explain?_____

2. What is it mainly, that you dislike about your partners?
Explain? _____

3. List five of your partner's best qualities?

1.

2.

3.

4.

5.

4. List five of your partner's worst qualities?

1.

2.

3.

4.

5.

5. What have you wanted to tell your partner, but couldn't before now? Explain

6. In what way do you see yourself in a successful marriage? Explain?

Frequently asked questions

(See answers following)

For couples in crisis:

Should I tell him I want marriage or should I wait for him to propose?

We just met and I gave him my phone number he hasn't called should I call him?

How do I know if he is really into me?

If one of you has been unfaithful in marriage should we renew our vows?

How much ignoring should I be expected to do with his bad habits. Where do I draw the line?

I am feeling like a second class citizen; we are living together and still not married.

I am feeling that I could have married someone better.

My husband has a control issues what should I do?

She neglects her responsibilities to me what should I do?

What should I do when he neglects me?

I just found out I am pregnant, should we marry?

Answers to the most frequently asked questions.

"Should I tell the guy I want marriage?"

Yes, it is in order to tell him you are looking for marriage. That does not necessarily mean you are seeking to marry him. Just for the records, you are merely defining to him what will be expected out of him in the event you both should fall in love.

Men marry whom they wish and when they wish they are aware that most respectable women are serious about their relationships and are expecting marriage out of it.

You might hold off on intimacy type relations, until you are at least engaged and sure you are about to marry, or until you are sure that he is right for you and that you are both in agreement that you are expected to make plans to marry.

There is nothing wrong with telling him you are wanting marriage, he is either going to marry you or he's not, set a deadline and open communications so that you can find out his intentions before too much of your time and emotions get involved.

Usually after approximately three months, you should be

able to determine if he is just going along for the ride of is he is falling in love with you.

Another tip is that most men who want marriage, will tell you up front they are looking for their wife, there are multitudes of testimonies from men who are married saying they knew she was going to be their wife when he first laid eyes upon her. If you are seeking marriage from your relationship and you haven't heard the word marriage from him within three months, you probably won't be hearing it, and you are probably wasting your time waiting for him to decide if you are the right one for him. Be cautious not to get caught up in a web where he wants to '*try you out first*' to see if you are right for him. Remember commitment comes first.

"Should I call him first?"

We just met and I gave him my phone number so he then left me his number. The answer is no. Remember you are a lady he took the liberty to get your phone number so it will be up to him to call you.

This is a little test to see just how interested he really is. No, he didn't lose your phone number, he is obviously not very focused, on you. I would wait a couple weeks then forget about him. Apparently, he got detained or distracted he is showing signs of someone who is not that much into you. At this early stage, this is a sample of what it will be like later on in the game it could be he is the not the focused type.

That would send a red flag if something truly came up

unexpectedly, he will find a way to reach you if he is truly interested. Men have a way of finding you if you are indeed the one for him; if a man is interested in you he will find a way to get you into his life.

"How do I know if he is really into me?"

There are ways you can tell if he is really in to you.

a. He will spend money on flowers and multiple dates.

b. He will act as though he is in love his demeanor.

c. He will call you regularly.

d. It's in his kiss you can tell a great deal about how he feels about you in his kiss.

e. He will want you to meet his friends and family.

f. He becomes jealous of you and territorial.

g. He will tell you.

h. He will talk about getting married

I. If he is really in to you he will prove himself to you and

He will confirm his love conviction to you

These examples are ways of telling if your mate is down for you!

"When should my husband and I renew our marriage vows?"

If one of you or both are found to be guilty of infidelity, yes

it would be to your advantage to renew your marriage vows; just to be sure you are sanctioned by God.

The Bible says God forgives us of our sins however, in the case of known infidelity, it would be comforting to know that you have been forgiven along with finding peace of mind at least; it is enough emotional drama that you will have to over come, not to have any doubt that you are recovering emotionally.

"Where do you draw the line with his bad habits?"

You will have to be the judge of how much pressure you can take regarding the negatives in your life. What is trash to one could be considered a treasure to another however, there is a thin line between right and wrong, just as there is a thin line between love and hate. There are degrees of abuse you should pick your battles. Since there is no perfect situation you will naturally be required to gage your own tolerance levels.

It will depend on how much abuse has been allocated? What are the damages? For example; if he is fornicating with another female naturally you will not tolerate that behavior; that is the worse type of abuse, with aids and sexually transmitted diseases out there in society, there is a real danger of subjecting oneself to that kind of devastation however, on the other hand if he is doing something such as, watching too much football on the weekend; that would be something negotiable that can alleviate a degree of the crisis

If he is making your life miserable you will find that there is a need to open the door to communications let him know how

he is making you feel; the flip side to this is that you should help him to open up to you; allowing you to find out how and why he is responding to you in a negative way. If he refuses to stop his aggravation, try ignoring him; to alleviate his annoyance if that doesn't work; you can separate from him until you reach a consensus. No one deserves to live a miserable life just to be a partner to someone who is selfish and inconsiderate. Life is too short.

"Should I move in with him without being married?"

You should never move in with a man that you are not married to if he really loves you he will do the honorable thing to marry you, if he has refuses to marry you; he is seeing you as a second class citizen. He is allowing you to live in with him and he thinks he is doing you a favor.

It will be up to you to stop the abuse; you deserve better than that type of treatment. Your body is designed to be more than a piece of meat provided for someone to use for their own satisfaction. Give him an ultimatum and set a date soon, if he does not honor you by the date, move out and find yourself a real man.

As difficult as it may be; sometimes you just have to dump that zero and find yourself a hero.

"Could I have married more upscale?"

I am feeling that I could have married someone better for me? If you are thinking it is greener on the other side, it is usually not. All relationships have their challenges, if you were impressed

enough with your husband to marry him; you should hang on to the impressive qualities that you once admired about him, if you married him you once loved him and you should try to get the romance back into you love life.

It appears that you are bored and maybe the marriage is not growing. It would be virtually impossible for an outsider to actually advise you, if your husband is performing adequately in your marriage without being there to see how your marriage is constructed and to evaluate the potential it has for fulfillment.

In your quest as you continue to search for answers as to why you are having those negative feelings? I do not recommend that you leave one partner to be with another and no it is usually not greener if you go on the other side. There will be occasional stumbling blocks from time to time in all relationships however, you may as well stay with your secured marriage unless there is some detrimental abusive issue that you are dealing with; if not, you should start enjoying your man and find ways to stimulate, grow and appreciate having a marriage.

The Bottom line is that his controlling is beginning to become unbearable for you.

"I think my husband is too controlling."

Did you know about his control issue before you got married? I am assuming his control issue was revealed to you in some small way before you married him. People do not have the capacity to change their personality type. What you see is what you get.

If he never showed you signs of his control issues before you

married him and he changed during the course of the marriage you should get counseling for the two of you.

Control issues can get pretty hairy and always stems from insecurities that can become complex and always reverts back to ones child hood. Control issues can make your life very miserable, no one should have to live being ordered around and controlled by another. You have a serious decision to make it will be for you to analyst and decide if his control issue is too severe, if so, I would recommend that you separate with him if you are unhappy or if he is causing your health to fail; until you can reach a consensus. By all means and get counseling if you stay with him.

There are degrees of 'control' ranging from being a strong leader to not allowing his wife to visit her mother. Where are you in that scenario? If the range of abuse is considered a slight case of abuse I would recommend you have your communications broadened and you should talk to a third party and see if you can convince him to see he has a problem.

"I am feeling neglected by her, whose fault is it?"

If you have chosen someone who has always been a cold turkey type, that is what you have chosen. You could try better planning; branching out in the areas that will stimulation her. Find out what she enjoys doing. Try weekly trips to the gym exercising together or increasing your activities together regularly will help stimulate your body and mind.

A wonderful relationship stimulator is found in sharing physical activities. Those are the activities that stimulate and

brings physical energy, your problem could be the mind is tired as well as the body, when that happens you will need to exercise both components, when generating and revitalizing your body and mind you are allowing those brain cells to become stimulated. *It is through the renewing of your mind that you become transformed.*

If there is a sudden change in her normal behavior pattern that could be the reason she has suddenly changed her behavior towards you, the best policy available to all relationships is to communicate as a primary tool in resolving your issues. Ask her if there is a problem with her? Get her reply if she replies yes, discuss it with her and come to a compromise that will please both. This might require counseling if you cannot get satisfactory results on your own. Counseling is recommended to help alleviate the devastation of the problem that is unresolved.

"I found out I am pregnant and we are not married should I marry him because of the baby?"

Marriage should be a result ranging from being in love to wanting to give of oneself, getting married due to a problem or mistake that you made such as getting pregnant for the purpose of covering up something, is not what is best for the child, rather the opposite, the child is better off living in an environment with his own single parent who is presenting the proper and adequate Christian environment; to marry for the purpose of giving the child a name, where there is fighting going on constantly is destructive for the child.

Marriage for the wrong reason will not sustain the marraige,

and will not benefit the child unless you are both in love with each other and both are willing to make the sacrifice of marriage. If you marry just for the sake of giving the child his name that could be grounds for a disaster, if there is no love for each other.

Getting pregnant does not mean you are both in love anything outside of being in love will offer to be a threat to the marriage. Love and sex do not have the same meaning, my answer to you would be no.

It would be a grave mistake to marry because you made a mistake by getting pregnant, if you choose to stay single you should take preventative measures to make sure this doesn't happen again, having one child to care for, as a single, will be difficult. It is not the end of the world when this happens; it happens everyday; whatever your choice will be make sure you keep your prayers in the midst of it all, God will show you the way, if you are following your Bible along with allowing God to use you. Be blessed and good luck to you in making the right decision.

To order Books Email to: msjudi9@yahoo.com or Call 469-765-5207. Mail your check or money order to: Cole Counselors P.O. Box 2602 Humble, Texas 77347. Please send your name and address and no of Books you are ordering. This book is $18.95 each. Shipping and handling is $3.50 per book.

This book is also sold online with major Book stores.

Ephesians 5-21-53

Submitting to one another in fear of God "wives submit to your

own husbands as to the Lord for the husband is the head of the wife as also Christ is the head of the Church and he is the Savior of the body.

Therefore just as the Church is subject to Christ so let the wives be to their own husbands in everything.

Husbands love your wives just as Christ also loved the Church and gave himself for her.

Nevertheless let each one of you in particular so love his own wife as himself, and let the wife see that she respects her husband."

God knows your thoughts and plans he will cause them to happen. We have an assignment and that is to be a witness to others who do not know the Lord Jesus or to those who are lost and have fallen. *To carry his cross* you can do it and do it according to the Gospel.

WISDOM KEYS"

The purpose for fasting is to deny oneself, to live in obedience, and to cleanse the body

The issue of fasting is defined as something one must do as a means of connecting with God, it shows a form of sacrificing or denying one self being obedience to God, whether it is giving up one meal for three days or not eating at all for three days or more just drinking liquids, or fasting for up to forty days for example, you can decide what method you will take in planning your fast.

God will see your fasting and he will bless you because of it.

What is intercession prayer?

This is a process where you are joining in prayer on the behalf of someone else's need. You are lifting them up before God in prayer. You are their representative it is considered a higher commission of prayer for the intercessor and is recommended for Christians. To pray that God will lead you into intercessory praying.

It is important for the male leader to understand that his female partner is there as his help mate. You are not there to help her; *she is there to help you* with your leadership planning. Make sure you are both submitted to God and on the same accord with God nothing less will work.

You are commanded to be fruitful and multiply.

Each and every one of Christian people belong to God therefore, with that in mind as faith believers how can one fail if he is in the word and working it? The Word works! If you work it.

First fruit giving: Is in addition to your tithe of 10% the more you give the more you can receive. It is the golden rule you reap what you sow.

Proverbs 3-9: 10

"Honor the Lord with your possessions and with the first fruits of all your increase so your barns will be filled with plenty."

Matthew 6: 31-34

Therefore do not worry saying "What will we eat or what shall we drink or what we shall wear?"

For your Heavenly Father knows that you need all these things. But seek first the Kingdom of God and his righteousness and all these things shall be added to you.

This book targets commitment, awareness and compatibility as three of it's allies incorporating their way into your life so that you can love again; this method will bring you hope for finding love it is equally important that once you find love you must find ways to keep it. There is a door key that will lead you into a new found world of freedom when you allow yourself to give love and receiving love again in return.

You can find your reason to live in a loving and successful way; by serving your Heavenly Father and using his guideline as you way of life your life leads a continual learning process.

When disobedient is allowed; the school of hard knocks will teach you with honors as well.

Taking Spiritual walks with God is your greatest assets in life and offers a feeling of worthiness that lends in taking the responsibility and having wisdom that is needed to become anchored in his Word. Finding your place in life; is where your life has become *transformed.* There is no diversion from God so you can enjoy the gift of life right now more than ever before.

God puts people in the paths of our lives to help us. This book is also here and available to accommodate you in your handling of your relationship crisis to help avoid devastation later on in your

life. We are all an intra dependent on one another and it will take all of the people of God on this great earth to apply their input to make this world a better place for all to live. God doesn't expect you to delegate selfishly holding your knowledge for yourself but rather to take his Gospel and apply it to glorify him and to save someone else from the devastation of divorce or in life.

We are strolling along the path of righteousness in your quest expecting to find your cherished love, I contend that with the rising crime rate, there is a need to address the increasing rates that are committed on the streets; the single household and single parenting is a problem and is anchored on out of order bases. Unattended it will not decamp on it's on and will continue to grow.

Useful Bible Scriptures:

John 10:10

The thief does not come except to steal kill and destroy I have come that they may have life and have it abundantly.

Who is the thief in your life? Everybody will encounter a thief in their lifetime, you probably have one lurking around you at this time. A thief is someone or it could be something that is robbing you from the quality of life; causing you to experience losses; the loss of your joy, your peace, or a good nights' sleep. There comes a time when you have to say no to the kids when they want to go here and there. Or maybe you will have to learn how to leave some of the work on your desk for tomorrow.

John 10: 27

God says Peace I leave with you. My peace I give it to you not as the world gives do I give to you. Let not your heart be troubled neither let it be afraid.

With a large percentage of the people being obese and continuously trying to take off the pounds it is obvious that a great deal of society is failing in being health conscious. Taking care of yourself involves eating the right food and the right portions when you have that nagging feeling going on inside your body, it is trying to tell you something often times, that you are making the wrong choices, especially in the food you are eating. Eating right implores you to be in good health you have to exercise and get a pattern going of getting a good nights' sleep.

Give God more of your time, if you are skimpy with God you are probably giving greatly to Satan and not even being the bigger guy you were meant to be, this will take away from God placing his hedge or protection around you. God says in his word that *he will fight out battles for us.* To be able to apologize when you are wrong or even if you feel that you were right just to keep the peace, if you can apologize you will be surprised at how much reward will come to you from being the peace maker. *Blessed is the peacemaker.* The simple things in life carry big rewards.

Jesus provides peace, seek it, pursue it and take a look at what and who is stealing from you; those things that are keeping you up and making you stressed and making you sick.

1Peter 3:8:10

All of you being of one mind having compassion for one another love as brothers be tender hearted be courteous.

Not returning evil for evil or reviling for reviling, but the contrary blessing knowing you were called for this that you may inherit a blessing. For he who would love life and see good days let him refrain his tongue from evil and his lips from speaking deceit let him turn away from evil and do good let him seek peace and pursue it for the eyes of the Lord are on the righteous and his ears are open to their prayers but the face of the Lord is against those who are evil.

To the husbands:

1 Peter 3:7

Husbands likewise dwell with them with understanding giving honor to the wife as to the weaker vessel, and as being heirs together of the grace of life, that your prayers may not be hindered.

Do your part to be healthy and happy set your mind to make it happen. Find ways to simplify your life.

Romans 14:**14**

The laws of Love:

I know without a doubt being fully persuaded by the Lord Jesus that there is nothing unclean of it self but to him that considers anything to be unclean it is unclean.

Yet if your brother is grieved because of your food you are no longer walking in love, do not destroy with your food be spoken of as evil.

For the Kingdom of God are not eating and drinking but righteousness and peace and joy in Holy Spirit.

For he who serves Christ in these things is acceptable to God and is approved by men.

Therefore let us pursue the things that make for peace and the things by which one may edit another.

Do not destroy the works of God for the sake of food all things indeed are pure but it is evil for man to eat with offense.

It is good neither to eat meat nor drink wine nor do anything by which your brother stumbles or is offended or is made weak.

Do you have faith? Have it to your self, before God, happy is he who does not condemns himself in what he approves.

But he who doubts is condemned if he eats, because he does not eat from faith for whatever is not from faith is sin.

Proverbs 4:1-6

Hear my children the instructions of a Father and give attention to know understanding for I give you good Doctrine do not forsake my law.

Let your heart retain my words keep my commandments and live get wisdom get understanding and don't forget nor turn away from the words of my mouth.

Do not forsake her and she will preserve you

Love her and she will keep you

In all you're getting get an understanding

Exalt her and she will promote you.

She will bring you honor when you embrace her

She will place on your head an ornament of Grace

A crown of Glory she will deliver to you.

Hear my son and receive my sayings and the years of your life will be many. These are your final scriptures that are related to you and your mate.

I Corinthians 7:2-5

Because of sexual immortality, let each man have his own wife and let each woman have her own husband. Let the husband render to his own wife the affection due to her and likewise also the wife to her husband. The wife does not have authority over her own body, but the husband does. And likewise the husband does not have authority over his own body, but he wife does. Do not deprive one another except with consent for a time.

Proverbs 31:10-12

For the heart of her husband safely trusts her. So he will have no lack of gain. She does him good and not evil all the days of her life.

Author's closing remarks:

In our Family Law firm we are confronted with so many different issues with people who are fighting and have issues that need to be resolved, each case is uniquely different.

Judith Carol Cole

I am of the opinion that legal practicing is meant to be creative you can create a solution or you can compound the problem by using little or no creativity, that makes the difference between a great law firm and mediocrity.

From the Author:

I am blessed to work in a Christian atmosphere, when I am working with my oldest daughter Stephanie, in our new family homeless Shelter outreach "The New Horizon Christian Outreach" this is our way of Ministering the word of God to the homeless and hungry.

My youngest daughter Ginger Byrd is an Attorney; currently, we established a family Law office. Since I am gifted with a business sense and organizational skills, together we make a great business team. After we decided to go into a private practice I moved to Humble, Texas to join her. This has been a whimsical journey. I have met with some top prominent Judges and other legal official. This opportunity has given me new and inventive opened doors and leaves me with a feeling of fulfilling my purpose in life.

*I am hoping that you will be inspired and brought to a higher awareness of what it will take spiritually to find your love life again. You can now use this Book **How to Handle Your Relationship** to strengthen your relationship by applying the valuable keys listed in this book. This book is uniquely designed to help you tear down the old for the purpose of rebuilding starting with yourself. Once you find that you have been delivered from self deprivation and set free*

from being your own enemy you will find you're new born again purpose in your life.

God reveals in his teachings that he has already turned things around in your situation. He was always there; your answer was there within you all the time. Far too many cases are reported where they find themselves looking in the wrong places for love resolutions.

Your Heavenly Father is love.

*Fr*om the Desk of Attorney Ginger Byrd:

Attorney fees and counsel are costly. You would be wise to remember these remarks as you apply this to your life:

"How you can achieve a successful life and relationship."

She Says:

Success equals opportunity plus preparation. One must first find their passion. We all possess certain gifts and talents. Success starts with the realization of what your gifts and talents are and then owning them. If you take your passion and add perseverance you will meet your goals.

Remember, a lot of money is just an added bonus to true fulfillment. True fulfillment comes from having purpose, implementing that purpose and watching the fruits of it grow.

I believe your purpose lies with your passion. Each one of us has it and the sooner we follow it, the closer we will be to true fulfillment.

Final closing prayer:

Heavenly Father, we come before you with thanksgiving in our hearts we are so thankful to have you as our Heavenly Father, we want to thank you for all your many blessings. There are so many blessings we cannot name them all. We give you thanks for giving us this life and blessing us within our lives. We love you more and more each day. We continue to ask you for our strength and to be saved by your grace as we continue to walk with you. Please forgive us when we fall, help us to get back up and become strong in your word.

As we close out this wonderful opportunity for the giving and sharing of your word in this book; we ask that you accept this book and use it to help those who are in need of it; as we claim our victory and declare that we have now; resolved our relationship issues by casting our cares over to you. In Jesus name we pray.

Amen.

Be Blessed!

To order this Book: available at major online Bookstores, Face Book or Mail to: Cole-Book P.O. Box 2602 Humble, Texas 77347 or call 469-765-5207 leave your name and phone no. a representative will call you back with ordering information.

$18.95 Shipping and handling is $3.50

msjudi9@Yahoo.com